Defining Eye: Women Photographers of the 20th Century

Women Photographers of the 20th Century

Selections from the Helen Kornblum Collection

Olivia Lahs-Gonzales

Lucy Lippard

with an Introduction by Martha A. Sandweiss

The Saint Louis Art Museum

Published on the occasion of the exhibition

Defining Eye: Women Photographers of the 20th Century

organized by The Saint Louis Art Museum

Edited by Mary Ann Steiner
Designed by Katy Homans
Manufactured by South China Printing Co., Ltd.

front cover:
Claude Cahun
French, 1894–1954
M.R.M. (Sex), 1936
No. 66

back cover:
Hannah Wilke
American, 1940–1993
S.O.S.—Starification Object Series, 1974
No. 67

Library of Congress Cataloguing in Publication Data
The Saint Louis Art Museum
1. Photography
2. Women photographers
3. History of photography
LCC 97-068149
ISBN 0-89178-047-5

Printed in Hong Kong

Contents

The exhibition *Defining Eye: Women Photographers of the 20th Century* celebrates almost two decades of collecting on the part of Helen Kornblum. Her commitment to the work of women photographers connects with the Museum's mission to represent art that reflects global diversity in areas of race, culture, and gender. In years of lively dialogue between Helen and our curators, her knowledge and passionate involvement, no less than her insightful suggestions for Museum acquisitions, have been an inspiration to us all.

Foreword

The range and striking quality of Helen Kornblum's collection are the result of her devoted interest in humanistic issues, her keen eye for powerful and beautiful images, and her avid study of photography in general and women photographers in particular. Her ongoing discussions with curators, dealers, artists and others who think seriously about photography make for a dialogue that is inclusive and ever open to new artists and insights.

Defining Eye: Women Photographers of the 20th Century features an international array of women photographers whose important contributions to the history of art and photography have provided a singular perspective on life, the self, our relationship to the world and to each other. Featured are both well-known photographers and others only recently restored to the medium's history. Most of the photographs in the collection are rare vintage prints, and many have never before been published.

While *Defining Eye* is a beautiful exhibition, it also has a societal agenda. Drawn from a larger collection, the exhibition is not meant to present a "final word" on 20th-century women photographers. Rather, it is the statement of a person who has an abiding concern for the broader topic of women's issues in our time and whose interest in art is expressed vividly in powerful images by women artists in this medium. The purpose in mounting this exhibition is not to summarize, but to open discussion, identify less-known artists, provoke inquiry, pique interest, engage the eye. We have enjoyed and admired Helen's collecting over the years and we greatly appreciate her generosity in placing it in the public arena.

The authors of the catalogue are Olivia Lahs-Gonzales, the organizer of this exhibition, and writer, critic, and feminist Lucy Lippard. They have each provided a thoughtful analysis of the collection as a whole and of the individual works within it. Martha Sandweiss, Director of the Mead Museum of Art, has provided a sensitive introduction to the collection and the collector. Mary Ann Steiner, the Museum's director of publications, has played a major role in her thoughtful editing and the many ideas she brought to shaping the project. Designer Katy Homans created a handsome and engaging format for the photographs to be looked at and the themes to be discussed. Bob Kolbrener and David Ulmer provided the photography for the catalogue. Arthur Rogers carefully attended to the details of framing the photographs.

Many of our colleagues and friends have been responsible for the success of this project. We thank Barbara Butts, Marianne Cavanaugh, Jon Cournoyer, Anna Cox, Jeanette Fausz, Karen Fiss, Sidney Goldstein, Davina Harrison, Jill Henderson, Carol Kickham, Lucy

MacClintock, Bonnie McKenna, Nick Ohlman, Pam Paterson, Helen Power, Kay Porter, Dan Reich, Tony Schlader, Stephanie Sigala, Rochelle Steiner, Diane Vandegrift, Jeff Wamhoff and Pat Woods. We are grateful to Deborah Bell, Buffie Johnson, Dina Mitrani, Peter E. Palmquist, Terence Pitts, and Virginia Zabriskie who all shared their time and information on particular artists and their works.

I want to express our special thanks to Helen Kornblum whose generous and open response to this venture has been unwavering. We join her in celebrating the achievements of fine women photographers through this unique and important exhibition.

James D. Burke
Director

Notes and Appreciation

Photographs of people and of themes dealing with psychological exploration have always captured my attention. Influenced by my work as a psychotherapist, I have been drawn to art that deals with the human condition. However, I became increasingly aware that the photographs I saw in museums and galleries were almost always by men. What began as a challenge, to find great photographs by women, became a commitment. That commitment intensified as I became more involved in women's issues, particularly women's health, a crucial area where medical research has been seriously neglected. My interests then converged. Women artists, like women as individuals, have suffered from being under-valued and often invisible. I am, therefore, grateful for the opportunity to highlight the accomplished and powerful work of women photographers and, in so doing, to contribute to deepening the understanding and recognition of women artists.

The presentation of this exhibition and the publication of this book have been truly colla-borative efforts. Their realization allows me to express my personal gratitude to the Museum's Director James D. Burke for his commitment and enthusiasm. The project has benefited greatly from the guidance of Barbara Butts, who nurtured it with her aesthetic and intelligent insights. I am extremely grateful to Olivia Lahs-Gonzales; she gave steadfast devotion to the exhibition and wrote a beautiful and thoughtful essay that reflects her knowledge and love of the medium. Special appreciation to Mary Ann Steiner for her skillful publication of the book as well as sensitive and careful editing of the essays. This publication and its contents are enriched by the artistic and skillful design of Katy Homans. I am thankful to Lucy Lippard for her compelling essay which provided a context to appreciate these artists in light of contemporary art and feminist theory, and to Marni Sandweiss for generously sharing her knowledge and support throughout the years, and her warm and discerning comments in the Introduction.

I have been helped by many artists, curators, dealers, and friends who have shared infor-mation, encouragement, and their enthusiasm with me. I deeply appreciate the spirited support and expertise of Judy Weiss Levy, Betsy Wright Millard, and Barbara Okun. Conversations with many artists who have discussed their work with me have deepened my understanding and inspired my efforts. Meridel Rubenstein and Joan Myers merit special thanks. There are many whose interest, insights, and friendship have made this endeavor especially meaningful for me: Stuart Ashman, Jodi Carson, Cheryl Conkelton, Marie Cosindas, Mary Engel, Karen Fiss, Cornelia Homburg, Sarah Lowe, Barbara Michaels, Graham Nash, Naomi Rosenblum, Rochelle Steiner, Barbara Tannenbaum, and Steve Yates.

Many dealers have shared with me their knowledge and passion for the medium: Janet Borden, Shashi Caudill, Carol Ehlers, Howard Greenberg, Tom Halsted, Susan Herzig and Paul Hertzmann, Edwynn Houk and Barry Friedmann, Robert Mann, Nancy Medwell, Lawrence Miller, Marc Nochella, Julie Saul, David Scheinbaum and Janet Russek, Andrew Smith, Spencer Throckmorton and Yona Bäcker, and Virginia Zabriskie.

I have been supported and encouraged by my friends and family. My husband Gene, our daughter Nancy, and our son Ted have shared my passion for the medium, even if they didn't always share my love for each photograph. For this and much more, I am deeply grateful.

Photography has secured its place as a vehicle for creative expression in the twentieth century, and women artists are in the forefront. I look forward to sharing in the creative visions of women artists who will make their mark in the twenty-first century.

Helen Kornblum

At its best, serious private collecting of any sort is both a private undertaking and a social enterprise, an exercise of pure passion and a display of tempered intellect. A devoted collector will pursue scholars and curators, dealers and artists, academic catalogues and newspaper clippings; she will fly off to see a new exhibition or drop everything to go hear an interesting talk. By this criterion Helen Kornblum, who assembled the photographs

Introduction

Martha A. Sandweiss

featured here, is surely a devoted collector. I say this from personal experience. She has called me up from the most improbable places, and sometimes at the most improbable times, to ask what I know or think about a particular photographic image. Do I like it? Is it unique? How would I evaluate its importance? If I could only buy a single photograph by this artist, would this be the one to get? These phone conversations—which I'm sure she has with any number of other people in the photographic world—inevitably end inconclusively. That is, I never know what she is going to do. That's as it should be. When push comes to shove, any good collector has to be prepared to act alone, following her intuitive sense that a particular object is the one that is right. She, after all, is the one who must live with it. All the conventional wisdom or expert advice in the world cannot make the picture hanging above the breakfast table or over the dresser meaningful. When it comes down to it, a collector has to be absolutely sure she is committed to the picture herself.

Over the past seventeen years, Helen has been making these broadly informed but private decisions and put together an impressive collection of photographs made by women working in the twentieth century. She began collecting as most collectors do—through a combination of chance, circumstance, and personal interest. Her parents were in the photographic supply business, so on the occasion of her father's 80th birthday in 1980 Kornblum offered to give a photograph in his honor to The Saint Louis Art Museum. The Museum suggested an image by the French photographer Henri Cartier-Bresson. *Rue Mouffetard* was the first picture she purchased, and she promptly gave it away.

Since then she has been holding onto things, and as her collection has grown in size, it has also taken on a particular character that reflects her personal interests. Collectors are sometimes likened to artists for the ways in which they carefully craft and hone a particular selection of visual imagery. But they can also be likened to autobiographers, with their thoughtfully shaped collections reflecting private tastes, politic interests, and social concerns. In this sense, Helen's collection tells one quite a lot who she is and what she cares about. As a woman and a psychotherapist, she i vork that reflects the distinctive experience of women in the twentieth cer her professional interests, it is no surprise that she gravitates towar at explores internal psychological struggles or the relationship ' ople. Landscapes have never much attracted her; it's the human nterest as well as her eye. "I can't separate my values from art," He images whose subjects seem in some way exploited by the photog s she gravitates toward pictures that seem to confer power and dignity on v .

In assembling a broad collection of work by women photographers, Helen is addressing what until recently has been an important lacuna in photographic histories. The historian Naomi Rosenblum, whose recent survey *A History of Women Photographers* (1994) goes a long way toward restoring women practitioners to their rightful place in the history of the medium, reviews the bare facts. Fourteen women appear in the 1982 edition of Beaumont Newhall's widely used *The History of Photography*. Eight of the 194 photographers mentioned in the George Eastman House publication *Masters of Photography* (1986) are women; in Mike Weaver's sesquicentennial history of the medium, *Art of Photography, 1839–1989* (1989) the count is four out of 96. One could suggest any number of reasons for this underrepresentation. But one is surely that women's work has been more difficult to find in easily accessible collections. Rosenblum writes, "Frequently women themselves, reflecting the attitudes of their own eras, did not regard their images as important enough to inventory and save. Unless kept safe by spouses or descendants, women's photographs often were discarded, tucked away in the attic, or stored in a musty bin at the local historical society." This is a key point. Historians can only write what they know about. Privately assembled collections—either those still in private hands or those that have become part of institutional collection—have always proved critical to photographic historians. Passionate private collectors existed well before institutional curators. When Beamont Newhall and Robert Taft were working on their photographic histories in the mid-1930s, they inevitably had to make generous use of the images and information they tracked down in private hands. What they saw, what they had access to, shaped what they learned and how they came to understand the art and practice of photography. As Helen, and others like her, build important collections of women's work and make these collections accessible through exhibition and publication, the content of photographic histories will begin to change.

Of course, if collections shape histories, histories also shape collections. It's probably fair to say that the pictures reproduced in the various editions of Newhall's *History of Photography* became more desirable as collectible objects as a result of their inclusion in the book. Many collectors—more faint-hearted than Helen—prefer that their purchases be validated by established authorities.

I congratulate Helen on deciding to share her collection in a public exhibition and catalogue; I know this can be difficult to do. Many collectors are deterred by the prospects of the bare spots on the walls at home, the glare of public scrutiny, the possibility of being second-guessed by critics and friends. But Helen has never imagined her collection as something that exists only for the enjoyment of her family. She has taken great pleasure in supporting and giving greater visibility to women artists, in asking how women's work provides a distinctive perspective on the human condition, in looking at how women photographers confront critical social issues. In presenting her collection for public scrutiny and enjoyment, she provides us all with an opportunity to join in the discussion.

Defining Eye: Women Photographers of the 20th Century

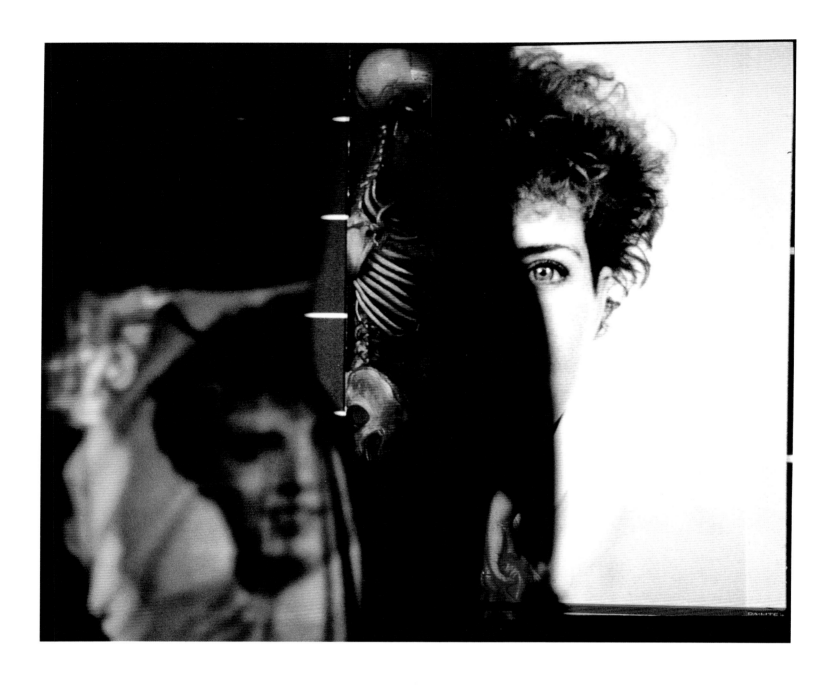

Aya Dorit Cypis
American, born 1951
The Body in the Picture: Bridget Shields, 1993
chromogenic color print
No. 27 (full image page 52)

Women have a unique experience in the world and of the world. Their vision constitutes another striation in our many-layered geology of cultural history. Their views, here expressed in photographic images, define and suggest, contemplate and scrutinize the world and our relationship to it. The women of photography have come here to share their viewpoints and relate their experiences—stridently, and subtly, with definition.

Helen Kornblum's vision provides a singular and important contribution to the discourse of photographic history. In contemplating the images by women photographers that she

Defining Eye/
Defining I

Olivia Lahs-Gonzales

has collected for almost two decades of passionate study, one is struck by the diversity of their viewpoints. In these images the photographers offer, state, assert, argue, and affirm their position in the world. As a collector, Kornblum is not only a supporter and a patron but also acts as a promoter of ideas. Art and life mingle. Psychotherapist, feminist, women's health activist, mother, and wife are among the roles that Helen Kornblum embraces. Her experiences of these photographs echo experiences within her own life. The continuously evolving collection is organized by her very passionate interest in the expression of the human condition, in social and political issues as well as aesthetic concerns, and for these reasons the collection is naturally exclusive as well as inclusive.

This exhibition and book are further extensions of her goal to reinforce the place of women photographers in the history of the medium while laying bare some of the very important issues that women confront on a daily basis. Women have, throughout the history of art, usually been relegated to the passive task of muse or object of desire and contemplation. With this exhibition and book, it is Kornblum's mission to contribute to the discourse which is already helping to change women's roles in artistic practice. By making public her collection she hopes that it will provide an insight into the very different life experiences of women.

The collection speaks of the complex relationships among ourselves, our environment, and our inner lives. Through documentary photography and photojournalism, portraiture, still-life, self-portraiture, and constructed tableaux, the artists featured in this collection define the world and the self. They share with us their experience of human interactions and intimate personal moments, and identify issues of social and political importance.

This essay is organized into two main sections: *Defining Eye* and *Defining I*. *Defining Eye* examines how photographers have shaped very powerful statements about the world, people and human relationships through the use of documentary photography, photojournalism and portraiture. These photographers define the world through visual means and give voice to those who are otherwise not heard. *Defining I* examines formalism and still-life as an investigation of the self; surrealism as a vehicle for the exploration of inner life; and how the self-portrait, masquerade and other feminist investigations have helped to question traditional notions of identity, confounded expectations of normality and gender, and questioned the nature of photographic reality.

The Defining Eye:

An Eye to the World

Women photographers of the twentieth century were innovators and independents, breaking both social and artistic boundaries. Bridging the centuries were such intrepid photographers as Frances Benjamin Johnston, Jessie Tarbox Beals, Gertrude Käsebier and Anne Brigman, all women who struggled to carve a place of independence in a world not yet prepared for them. In the short but artistically influential years between the world wars, women continued to break boundaries. Some clearly were outspoken feminists; others would prefer to be seen in the context of the whole history of the medium. In examining the work of these diverse artists, it is important to look at the social, political and economic contexts in which their photographs were made.

The common goal these women share is to define and assert a position, expressed through the medium of photography. Quickly recognized as a "democratic" medium, photography was taken up by many women as a profession or avocation. As a modernist mode of communication, photography developed from a medium that acted as a purveyor of "truths" and an outlet for personal expression to a medium which posed questions and confounded expectations. Since its invention it has become a forceful communicator of social issues and a dynamic with which to effect change.

Documentary Photography and Photojournalism

Defining the world through visual means is one of the goals of documentary photographers. Another is to give a voice to those who might not otherwise have been heard. Photographers like Frances Benjamin Johnston, Jessie Tarbox Beals, Marion Post Wolcott, Dorothea Lange, Esther Bubley, Graciela Iturbide, and Mariana Yampolsky pursued a mission to educate or effect change. Others like Lisette Model, Diane Arbus and Ruth Orkin chose a "documentary style" to present an aspect of social life which stemmed from their own view of the world. In this group of diverse images the central theme is that of an outspoken position on life and on the world.

One of the first women to succeed in the previously male bastion of journalism was Frances Benjamin Johnston. She and her colleague Jessie Tarbox Beals covered myriad subjects in a direct and unemotional style that helped define a standard for photojournalism. Both successful photographers, they also established studios producing celebrity portraits and images destined for commercial purposes. Here, Johnston employed the same "straight" approach in her photography, whereas Beals sometimes utilized the more popular Pictorialist aesthetics, producing "genre" images like *Little Girl with Hairbow* (see No. 15).

Johnston's photograph, *Penmanship Class*, 1900 (No. 1), commissioned by the Department of Education of the District of Columbia, demonstrates her attention to composition as well as to fact. Johnston "maps" the classroom, carefully giving the viewer all the necessary information. Although the teacher is clearly posed, the expression on her face brings a sense of humanism to the scene. She and the student with whom she interacts smile in reaction to the camera. Johnston was aware that Pictorialism was the dominant photographic movement in the late 1800s, but her training had been in journalism, and her technique fitted the subjects she covered. *Penmanship Class,* along with sensitive images from her study of the

Hampton Institute, a school for Native and African-Americans, earned her a medal at the Paris Exposition Universelle in 1900.

Town Meeting, Vermont, 1940 (No. 2) by Marion Post Wolcott is similar to Frances Benjamin Johnston's work in its studied composition. Made during Post Wolcott's time with the Farm Security Administration (FSA), the photograph shows a woman assertively addressing a town meeting (the subject itself drew the collector to the image). Although the photograph appears to be a detached and descriptive document, we become quickly connected to its humanity, noticing the direct and rather skeptical gaze of a centrally located figure. Other people in the crowd also look back at us. Through this interaction, we are actively engaged as participants rather than mere observers.

Post Wolcott was particularly sensitive to the problems of women farm workers, and she keenly felt the differences between a man and a woman's experience in the world. Roy E. Stryker, Director of the FSA, was supportive of the women photographers working for him and was aware of their potential to impart a unique perspective in the communication of the Administration's goals. He, too, was subject to the boundaries imposed by society on women during that time.

Dorothea Lange, who has been called "the supreme humanist," gave up a successful career as a portrait photographer when the events of the Depression made her reassess the direction of her work.[1] The masses of unemployed, the bread lines, the longshoremen's strike, all convinced her that she needed to document the reality of life. Lange was hired by the FSA in 1935 to continue the series of photographs of migrant workers that she had already begun in California. There she and the economist/activist Paul Taylor (whom she married in 1935) studied migrant harvesters. They helped turn public attention to the plight of farm workers and prompted government funding of relief programs. *Woman and Child, San Joaquin Valley*, 1938 (No. 3) is an evocative image in which Lange underscores the isolation of a traveling, jobless, homeless family debilitated by the hardships of the Depression. Focusing on the mother and child in the darkness of their covered vehicle, the image reveals that Lange knew how to capitalize on effects created by dynamic composition.

Isolation and alienation in the transience of travel are also communicated in Esther Bubley's poignant image of a small child clutching her mother's pocketbook (No. 4). It is the immense purse which comforts the child as much as the presence of her mother who is actually outside the image's frame. Bubley probably felt a similar sense of isolation as a woman traveling on her own in the South. Post Wolcott also had difficulties, but both women were able to overcome these social obstacles. Trained as a professional photographer, Bubley was hired by Roy Stryker when the FSA photography section became the Office of War Information in 1943. In the same year, Bubley was assigned to document America's bus system and spent six months on the road. It was during this first trip that *Bus Story, NYC* was made.

Like Dorothea Lange, Consuelo Kanaga's experience of the San Francisco longshoremen's strike and other events during the Depression changed the way she photographed. Her

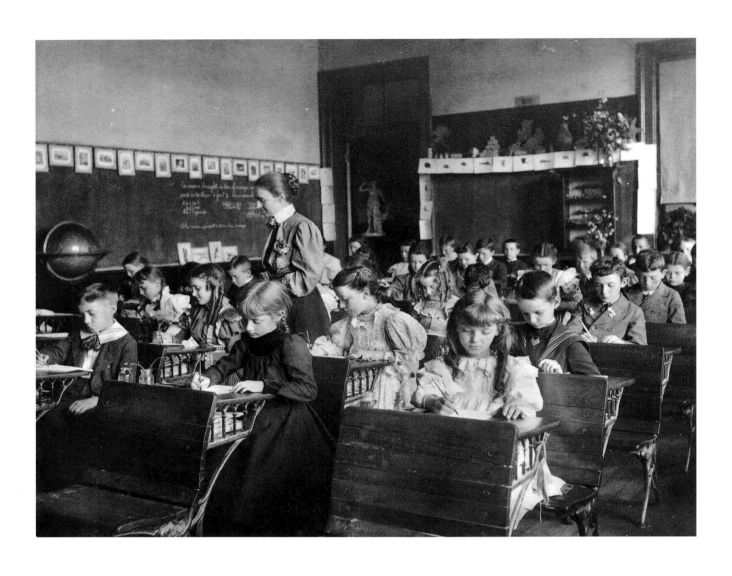

Frances Benjamin Johnston

American, 1864–1952

Penmanship Class, 1900

platinum print

No. 1

Marion Post Wolcott
American, 1910–1990
Town Meeting, Vermont, 1940
gelatin silver print
No. 2

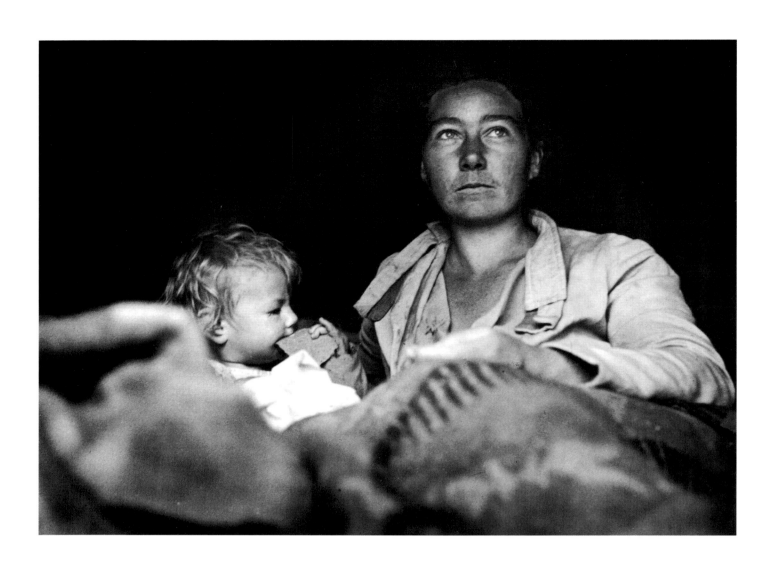

Dorothea Lange
American, 1895–1965
Mother and Child, San Joaquin Valley, 1938
gelatin silver print
No. 3

20

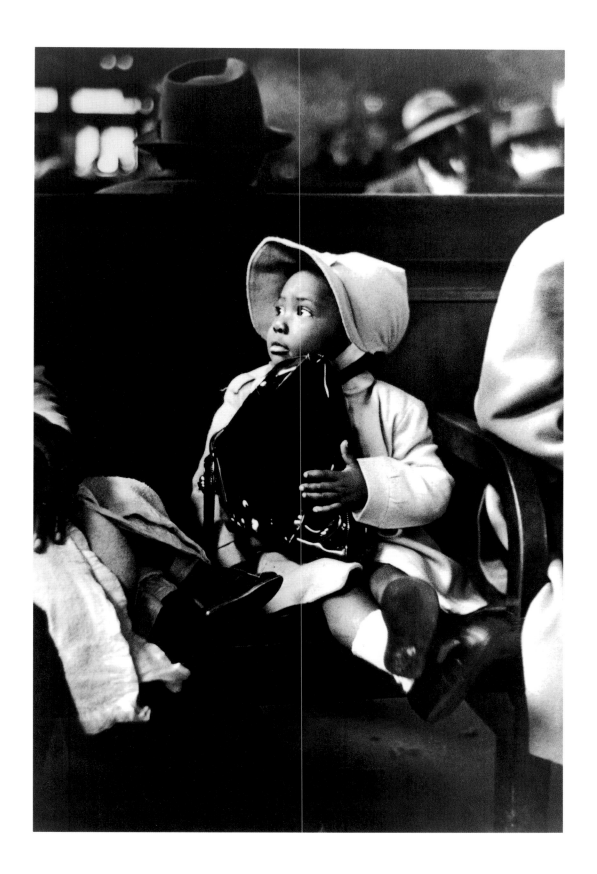

Esther Bubley

American, born 1921

Bus Story, NYC, 1943

gelatin silver print

© Esther Bubley, Courtesy Deborah Bell, NY

No. 4

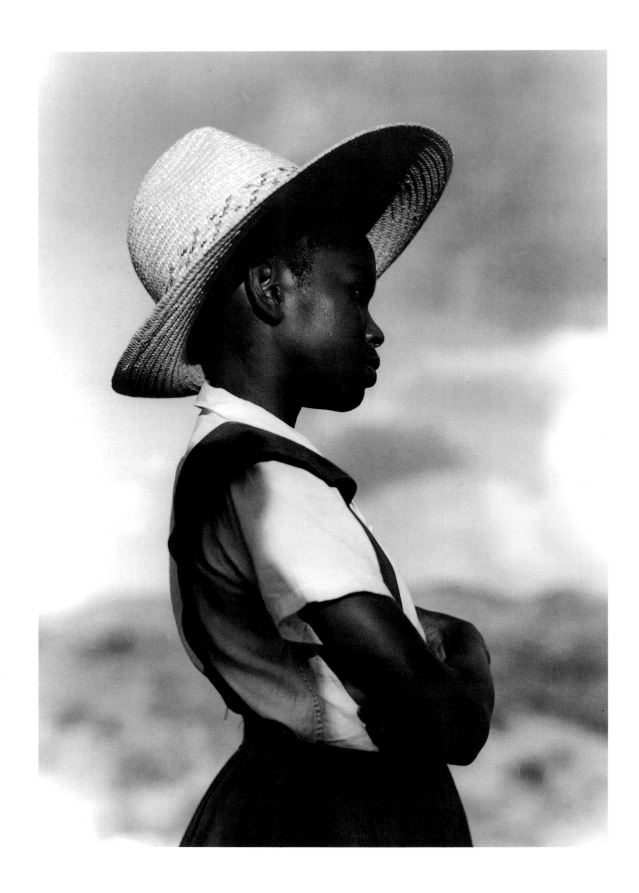

Consuelo Kanaga
American, 1894–1978
School Girl, St. Croix, 1963
gelatin silver print
No. 5

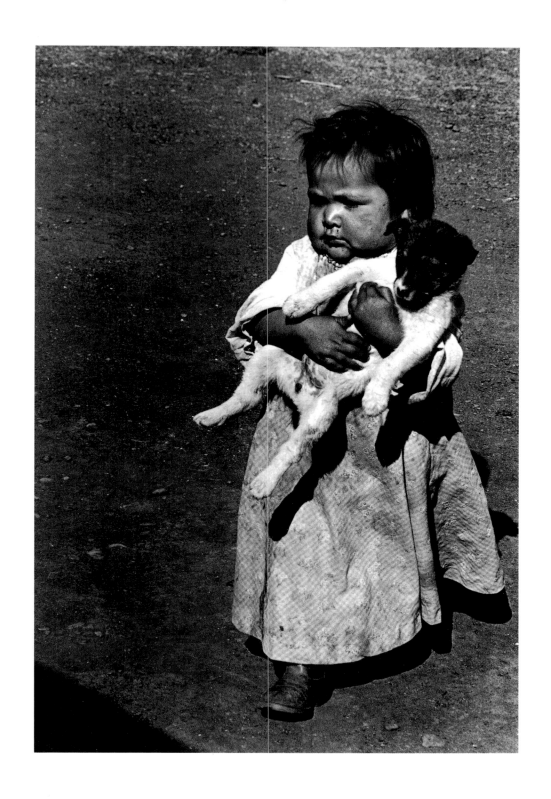

Graciela Iturbide
Mexican, born 1942
Mujercita, 1981
gelatin silver print
No. 6

awareness of the poor and disenfranchised grew as she traveled. As a photojournalist, she had covered everything from brides to striking pea pickers,[1] but assignments like the one to photograph striking dock workers were the most satisfying to her. Kanaga retained a lifelong concern for humanitarian issues and a sensitivity for people of color. Throughout her career, Kanaga visited African-American communities around the United States, as well as Diaspora communities in the Caribbean, making sensitive and ennobling portraits.

Kanaga was probably inspired by the images of Appalachian residents made by Doris Ulmann in the 1920s and 1930s (see No. 32). Unlike Ulmann, however, Kanaga did not romanticize the people that she photographed. Instead she emphasized the power of the subject by using a low camera angle, often filling the frame completely. With the light behind her, she framed her subjects against a white sky. The resulting images are a balance of aesthetic and social concerns, neither disengaged documents nor constrained by a traditional portrait aesthetic. Kanaga's portraits reveal the relationship between the photographer and the subject as an intimate interaction. Caught in reverie, the child in *School Girl, St. Croix*, 1963, (No. 5) presents an aura of melancholic introspection echoing Kanaga's awareness of the indignities suffered by African-Americans during those years.

Although Manuel Alvarez-Bravo is credited as an important influence on Latin-American photographers working in the documentary style, the roots of Latin American social documentary photography also stem from the activist prints and murals made by artists like José Clemente Orozco, Diego Rivera and David Alfaro Siqueiros in the 1920s, 30s and 40s. The Taller de Gráfica Popular, a collaborative of leftist printmakers in Mexico, was one of a number of centers of artistic production where artists disseminated their political ideas through inexpensive woodcuts and linoleum prints. Mariana Yampolsky, a member of the Taller de Gráfica Popular, Graciela Iturbide, student of both Lola and Manuel Alvarez-Bravo, and Flor Garduño (to be discussed later) all have assimilated the formal models of Manuel Alvarez-Bravo and the reformist ideas of revolutionary artists to create images that are both strong in aesthetic concerns and in humanistic ideals.

Graciela Iturbide, who has been documenting the powerful women of the town of Juchitán in Oaxaca, Mexico since the late 1970s, immerses herself in the everyday lives of the matriarchs of Juchitán. She shares meals, attends marriage ceremonies, has her hair braided, and assists the Juchitecas at market. On the whole, the images that Iturbide makes in Juchitán reflect an intimacy between the photographer and the women in the community. In *Mujercita* (No. 6), Iturbide catches the power and determination on the face of the diminutive human being as she tightly holds the small dog. Kornblum points out that the little girl, like the child in Bubley's photograph, holds what in psychological terms is a "transitional object," something that represents the mother in her absence. Holding such an object keeps a child connected and feeling safe. Iturbide's composition stresses both the child's isolation and her power: the photographer's aerial vantage point gives a sense of isolation, yet the child's force within the frame creates a sense of power.

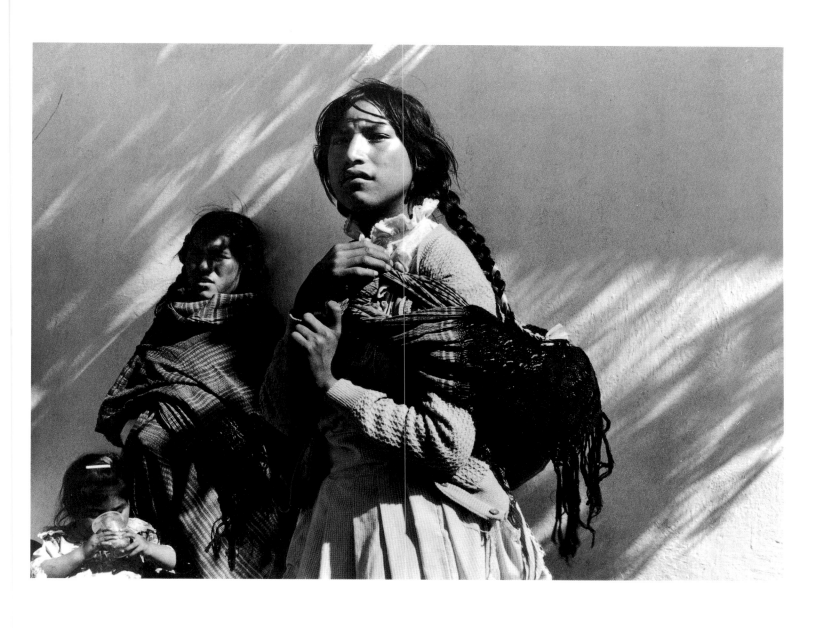

Mariana Yampolsky
Mexican (born U.S.), 1925
Mujeres Mazahua, 1989
gelatin silver print
No. 7

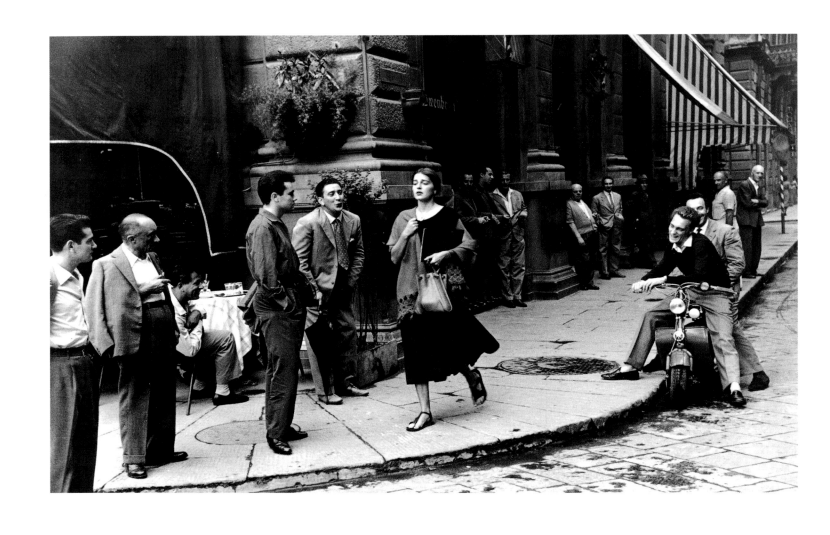

Ruth Orkin

American, 1921–1985

American Girl in Italy, 1951

gelatin silver print

© 1952, 1980 Ruth Orkin

No. 8

Another photographer who has spent years documenting and preserving women's roles in the traditional cultures of rural Mexico is Mariana Yampolsky. Intensity, dignity and skepticism are in the faces of the Mazahua women in Yampolsky's graphically powerful image *Mujeres Mazahua*, 1989 (No. 7). Yampolsky records the lives of Mazahua and Otomi women; often abandoned by their husbands, they lead lives of struggle and determination.

The Flâneur

The poet and philosopher Charles Baudelaire used the word *flâneur* to describe a person who experiences the environment as an observer, using these "spectacles" to create literary or artistic works. The term is consummately suited to describe a particular breed of documentary or street photographers who "capture" the passing moment with their cameras.

Although better known for her portraits of noteworthy personalities, Lotte Jacobi also pursued street photography with the keen eye of a *flâneur*. If her portraits were meant to be devoid of personal expression, then street photographs were the outlet for her own voice. Taken the year before Jacobi's flight from Germany in the face of growing Nazism, Jacobi's street photographs underscore the changing atmosphere of the city. Caught in mid-stride, the blurred figures in her works evoke a sense of dislocation. In her photograph of a small child holding a lollipop (No. 9), Jacobi has created a feeling of transience by skewing the horizon and closing in on the child. A truncated figure in the background further underscores the effect of movement and dislocation.

Ruth Orkin can also be described as a *flâneur* who observed, recorded and shared her experiences through her photography. Orkin's famous image *American Girl in Italy* (No. 8) was created to illustrate an episode that Orkin had experienced or witnessed many times. Her image of the harassed young woman on the streets of Rome is a powerful depiction of a phenomenon that seems to transcend time and culture. The young woman's expression echoes a feeling that many women have shared, as men who, emboldened by the strength of their number, surround the woman like a pack of hungry hyenas. The photograph, made on the second take, was a collaboration between Orkin and fellow traveler Jinx (Ninalee) Allen (now Craig) and, unlike Robert Doisneau's controversial staged photograph of a kissing couple in Paris, it nevertheless recorded the spontaneous reactions of the men in the street. Orkin's photo essay about a single woman traveling alone in Europe, in which *American Girl in Italy* was included, was later published in *Cosmopolitan*.[2]

Looking and asserting were integral to the photographs that Lisette Model took on the Promenade des Anglais in Nice in 1934 and that probably most closely exemplify the working methods of a *flâneur*. These images, which documented the point-of-view of the photographer as much as the social climate in Nice, show the bourgeoisie in all its vain and disagreeable glory: a woman and her dog alike in features; a fat man looking self-satisfied, and the *Famous Gambler*, 1934 (No. 10), whose behemoth valor and excess are observed from behind. To be sure, Model was critical; perhaps because of the nature of her upper-class background, perhaps because of the Marxist circles in which she moved. With

Lotte Jacobi

American (born Germany), 1896–1990

Child with Lollipop, 1934

gelatin silver print

No. 9

Lisette Model

American (born Austria), 1901–1983

Famous Gambler, French Riviera, 1934

gelatin silver print

© Lisette Model Foundation,

Courtesy PaceWildensteinMacGill, New York

No. 10

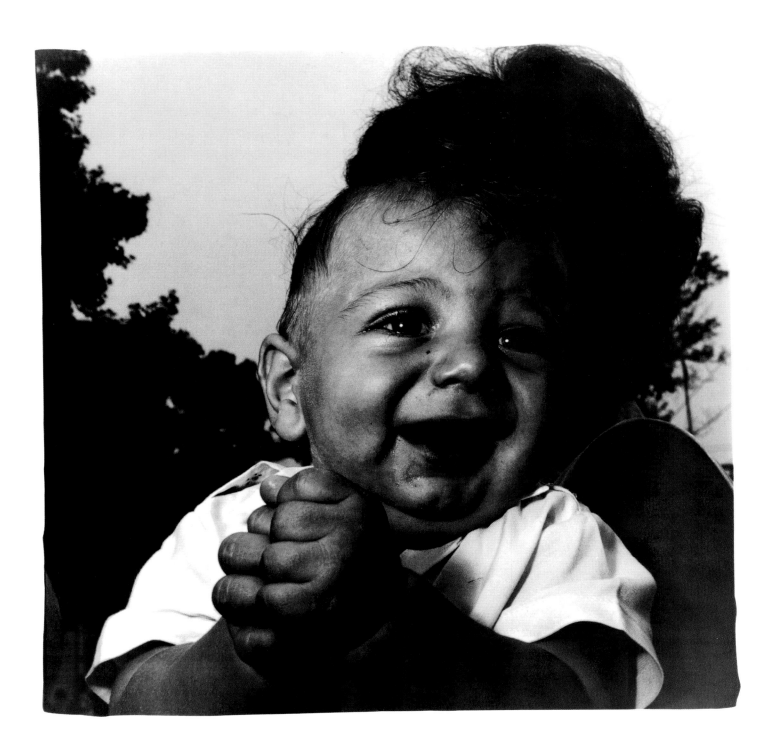

Diane Arbus

American, 1923–1971

Loser at a Diaper Derby, 1967

gelatin silver print

© 1972, The Estate of Diane Arbus

No. 11

photographs like these she made public her thoughts about life around her, while remaining guarded about the details of her own life.

Diane Arbus learned a great deal from her mentor Lisette Model. The latter's famous dictum "Shoot from the gut" encouraged uncompromising visual statements. Arbus was a *flâneur* who photographed scenes that revealed the unusual lurking beneath the banalities of everyday human existence. She sought out the discordant notes of these moments. Diane Arbus's portraits were often the result of an intense cooperative symbiotic relationship with her subjects. The subject, very much aware of "being photographed," posed for the camera and helped define an "image" of himself or herself. Susan Sontag has argued that Arbus looked to the fringes of society to subvert her own privileged childhood.[3]

In *Loser at a Diaper Derby* (No. 11), Arbus's point of view brings us close to the distilled emotion of the child presenting a vision of downright grief. The title ironically suggests that this is a commonplace event, yet it seems to have monumental importance for the participants. We are at the same time repulsed by and drawn to this child. Arbus here plays with the traditional "Madonna" image by presenting a scene that is not blissfully radiant. The mother, an undefined shape in dark shadow, pulls us into an intimate and discomfiting view of the tribulations of motherhood.

Surreal Realities

The street has offered many artists an opportunity to create surreal imagery. Chance juxtapositions of people or objects, when coupled with photography's illusion of "truth," reveal the symbolic potential of the quotidian world. Photographing in the ethnic and working-class neighborhoods of New York, Helen Levitt, too, is a *flâneur*, working in the genre of street photography which Henri Cartier-Bresson developed in the 1930s. Levitt has chronicled domestic life on the streets of New York for five decades, seeking out and encapsulating the ever-changing fabric of the vibrant city. She often finds an undercurrent of the surreal within the theater of the real. Her classic *Untitled, New York* (No. 12) is an example. Sandra Phillips points out that this image records a "moment of transfixed play, of children transformed by fantasy,"[4] an aspect of the image that assists in elevating the moment to heightened surreality.

Moments of transition and the special world of children struck a chord with Levitt. Masks and shrouded faces recur in her images of children, as she focuses on their enactment of various alternate realities. Taken on Halloween, *Untitled, New York* reminds us that this holiday offers both children and adults a sanctioned departure from one's identity and a chance to explore other aspects of the self. Street play can also be seen as a form of surreal interaction with the environment. The street is a space that allows an energetic and encompassing relationship with the exterior world. Boundaries are traversed and subverted as children climb the sides of buildings, telephone poles and trees, while fantasies are lived within the "theater of the real"—the street.

The surrealist spirit is even more evident in Inge Morath's photograph *Siesta of a Lottery Ticket Vendor, Plaza Mayor, Madrid* (No. 13), taken in Madrid in 1955. Morath credited

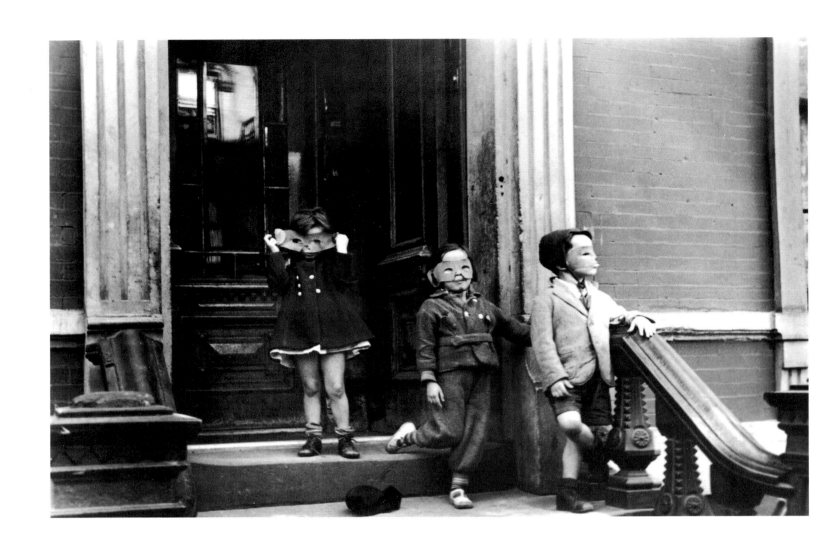

Helen Levitt
American, born 1913
Untitled, New York, 1940
gelatin silver print
No. 12

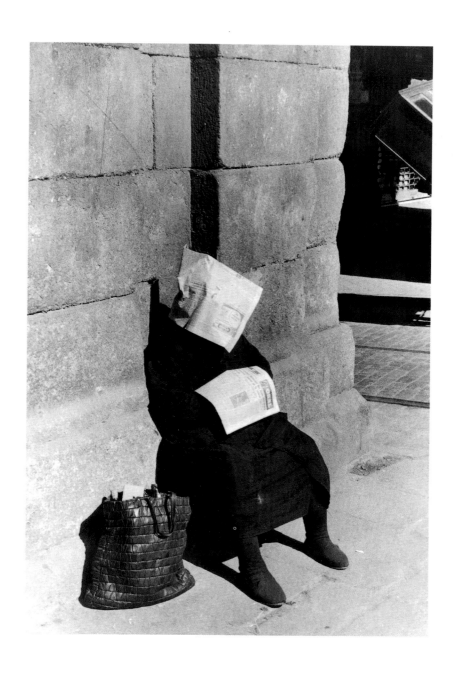

Inge Morath
American (born Austria), 1923
Siesta of a Lottery Ticket Vendor, Plaza Mayor,
Madrid, 1955
gelatin silver print
© Inge Morath and Magnum Photos
No. 13

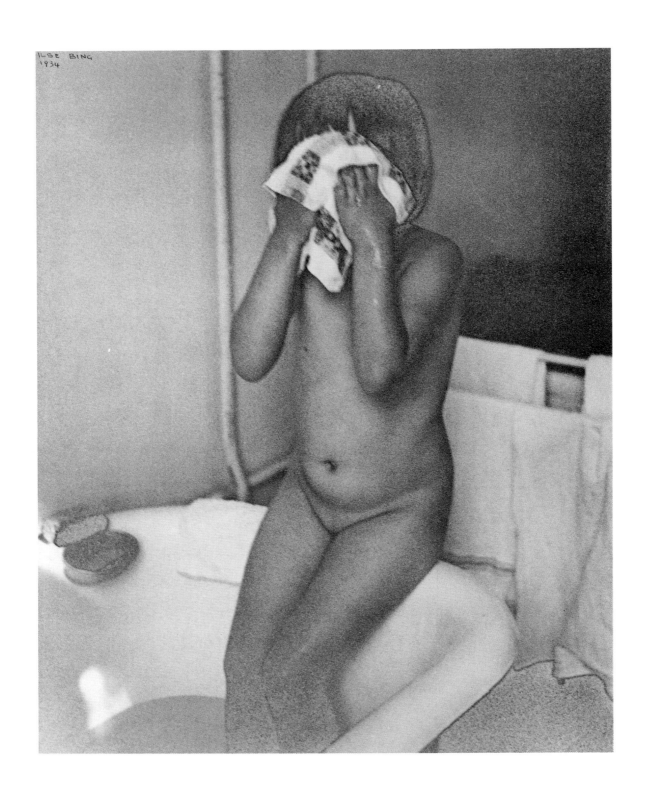

Ilse Bing
American (born Germany), 1899
Christa on Edge of Bathtub, 1934
solarized gelatin silver print
No. 14

Cartier-Bresson with exposing her to surrealist art. Spain in particular, with its potent religious rituals, invoked in Morath a heightened sensitivity to these types of images, so that the newspaper-covered face and hands of the woman evoked for her the shrouded figures of religious iconography. Morath calls this photograph her "Goya-woman" and sees in the image a kind of tragi-comedy, both enigmatic and amusing.

Everyday life thus presented photographers like Inge Morath, Helen Levitt and Ilse Bing with serendipitous situations that played to the themes of surrealist thought. These photographers, like their male counterparts Henri Cartier-Bresson, Brassaï, and André Kertész, chose to capture chance moments which played upon their subconscious. Ilse Bing moved to Paris from Germany in the fall of 1930 and immersed herself in the fervor of that artistic community. She was successful as a photojournalist, but adhered to the philosophy of melding artistic expression with documentary humanism. Time, space and chance were the components of her photographs.

Bing was drawn to surreal subjects, exploiting the film's grain structure while manipulating the tonal range of the print to convey scenes of dream and imagination. In 1934, the year in which *Christa on Edge of Bathtub* (No. 14) was made, she began to experiment with solarization, applying the technique to many of her night photographs. Solarization reverses black and white tones and creates a halo effect of distinct lines; it was favored by the Surrealists for its capacity to render the effect of dream and alternate realities. Double exposure, montage, solarization and negative printing were all techniques used by the Surrealists to alienate reality and establish an alternate state. In *Christa on Edge of Bathtub*, the coarse grain pattern and subtle solarization, coupled with the narrow tonal range, create a sense of disproportion. Bing exploits these effects, transforming the figure of the child into an apparition charged with a mysterious new life.

The Portrait Women photographers have defined themselves through their images and have often defined others in representation. These representations—portraits—are a collaboration between the subject and the photographer. They can reflect the photographer's personality as much as that of the sitter. Portraiture is an exercise in balancing personal with socially constructed experiences. The outcome, an image of the sitter, is at once a substitute for the original, a fiction, a delineator, a commodity, and the object of the viewer's inquisitive gaze. A portrait has the ability to sanction the stare, doing as much to reveal a personality as it does to transform it. It also has the overwhelming ability to reveal the personality of the maker: the definer is defined.

Gertrude Käsebier is one of the best known of the pioneer women photographers. Her standing amongst her Pictorialist peers was so high that the first volume of *Camerawork* was devoted solely to her work; many of the women featured in this catalogue have credited Käsebier with having inspired their own careers. Beginning her own career late in life, Käsebier drew extensively on her experiences, both positive and negative, of domestic life.

Her images of children often emphasized their independence and reflected her progressive attitudes towards child-rearing.

Käsebier strove to capture the individuality of the sitter and demanded simplicity in the design of her photographs. Although she vehemently denied any imitation of Old Master paintings, she sometimes dressed her subjects in costume and used painterly techniques like gum bichromate and platinum printing to produce images which reviewers often compared to Rembrandt or Van Dyck. *Untitled* (*Portrait of a Young Girl*), 1906 (No. 16) is one such example in which the child's open expression of self-confidence counters the image's more formal qualities.

Navaho Weaver, 1933 (No. 17) by Laura Gilpin similarly engages the viewer with an open gaze. It is a direct and formal portrait, unlike Gilpin's earlier, more romantic depictions of Native Americans. Her relationship with the Navaho was fostered by her friendship with Betsy Forster, a field nurse among the Navaho of Red Rock, Arizona. Over continued visits to that community, Gilpin's ideas of how to represent the people there changed dramatically, and she discarded romanticizing soft-focus effects for a more direct, documentary style.[5] Gilpin made the Navaho people and their lands her life's work, publishing books, giving lectures and making slide presentations to create awareness of Native American cultures.

Like Gilpin, Lola Alvarez Bravo highlights her subject's internal power and assurance. The photographs that Alvarez Bravo made of the painter Frida Kahlo between 1944 and 1945 belie the sitter's fragile health and show a woman who is confident and willing to examine and reveal her inner self (No. 18).[6] Kahlo spent a lifetime looking within herself, exposing her feelings to the world in unabashed candor. Kahlo's face, familiar from her many self-portraits, has become an icon. Alvarez Bravo's photographic portraits of the painter, interacting with our memory of the paintings, seem to ricochet one's concepts of reality and construction off one another. Kahlo, like a performance artist, utilized Alvarez Bravo's photographs as an avenue for self-investigation. They provided another means to communicate her multi-layered persona.

Titled *The Woman*, (No. 19) Flor Garduño's portrait of a woman holding a string of iguana is a fusion of cultural influences. Garduño successfully merges the techniques of formal portraiture and classic "documentary style" with aspects of Surrealism. In her photographs Garduño addresses issues of identity within the native cultures of Mexico. She exposes the remnants of ancient society while noting how New World influences have come to mingle. It is precisely in her mixture of artistic traditions and her attention to cultural changes that a kind of "*realismo magico*" is created.

Like Frida Kahlo in Alvarez Bravo's photograph, or the woman portrayed by Garduño, *Tiny* (No. 20), photographed by Mary Ellen Mark, defines herself forcefully and confrontationally through her stance, her attire and her gaze. One of few formal portraits in Mark's *Streetwise* series, the photograph presents Tiny in a Halloween costume, keenly aware of the camera's power to create an "image" of her. One of Mark's most memorable and poignant

photographs, this image shows Tiny drawing the mask of an alternative persona across her face. The girl's attitude here contradicts the vulnerability suggested in most of the other portraits of her in the series.

Mark's *Streetwise* project evolved from a *LIFE* Magazine story on Seattle's street children in 1983. Acknowledging that a woman photographer has some advantage in gaining access to and trust from her subjects, Mark turned the assignment into an extended photo essay and film. Using quotes from the children themselves, Mark gave voices to her subjects. The photographer, who has kept in touch with Tiny and others, added a postscript to the text in which she updated the viewer on the fate of a number of the children she photographed. The publication of the story did not change the circumstances of the people she depicted, but the compassion and respect she has for these young people have caused her to take the role of active witness rather than savior: "You have to let them live their lives.... You have to respect it for what it is...."[7]

"Why would you want her hanging in your house?" was a question Helen Kornblum was asked when she expressed interest in *Woman, Locket, Georgia*, 1936 (No. 21) by Margaret Bourke-White. But to Kornblum, the woman's face revealed a spirit of survival and courage. Photographer Doris Ulmann once remarked "A face that has the marks of having lived intensely, that expresses some phase of life, some dominant quality or intellectual power, constitutes for me an interesting face. For this reason the face of an older person, perhaps not beautiful in the strictest sense, is usually more appealing than the face of a younger person who has scarcely been touched by life."[8] Mainstream culture has not often allowed the representation of the aging female body, as society dictates a pursuit of youth and beauty in women. While women are expected to remain beautiful, men's lines and wrinkles are considered "distinguished." In addition, a recent backlash against feminism has brought back both the "waif" and the voluptuous bombshell as fashion ideals. *Woman, Locket, Georgia* speaks of the hardships of the Depression and of the tenuous relationship between photographer and subject. A woman seemingly uncomfortable with the camera, she stares us down with defiance and grim determination.

Anne Noggle, a photographer whose images have investigated the nature of body image and aging, was a pilot during World War II and later a crop duster. In 1986, a reunion of the Women Airforce Service Pilots (WASPs) inspired Noggle to create a portrait document of these women 45 years after the war. Her book, *For God, Country and the Thrill of It*, emphasizes the remarkable contribution these women made to the war effort. A historical record as well as a journey of remembrance, it illustrates these vibrant women both in snapshots from their tours of duty and in formal portraits taken by Noggle during the reunion. Her portraits are as much a statement about aging as they are a record of the women's vitality and perseverance. Proudly and directly engaging the viewer, the women pilots of World War II stand confident of their identity. Shirley Condit deGonzales (No. 22) looks the least comfortable, probably because she had to stand still for a long time, as the ash on her cigarette indicates, but nevertheless she confronts the camera and our gaze.

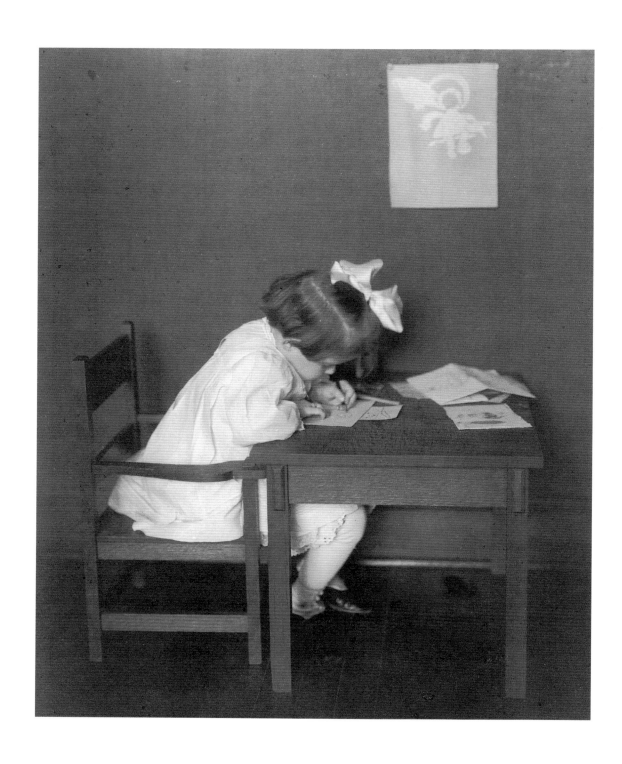

Jessie Tarbox Beals

American, 1870–1942

Untitled (Little Girl with Hairbow), 1908

platinum print

No. 15

Gertrude Käsebier
American, 1852–1934
Untitled (Portrait of a Young Girl), 1906
platinum print
No. 16

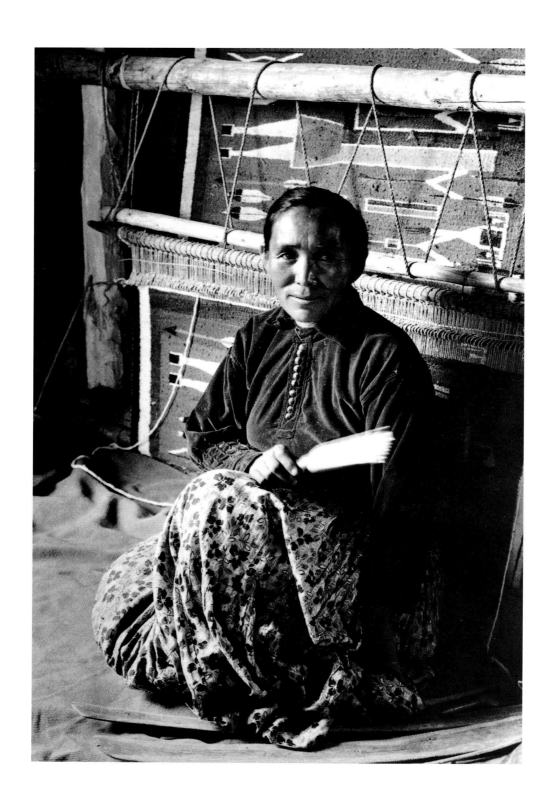

Laura Gilpin

American, 1891–1979

Navaho Weaver, 1933

platinum print

No. 17

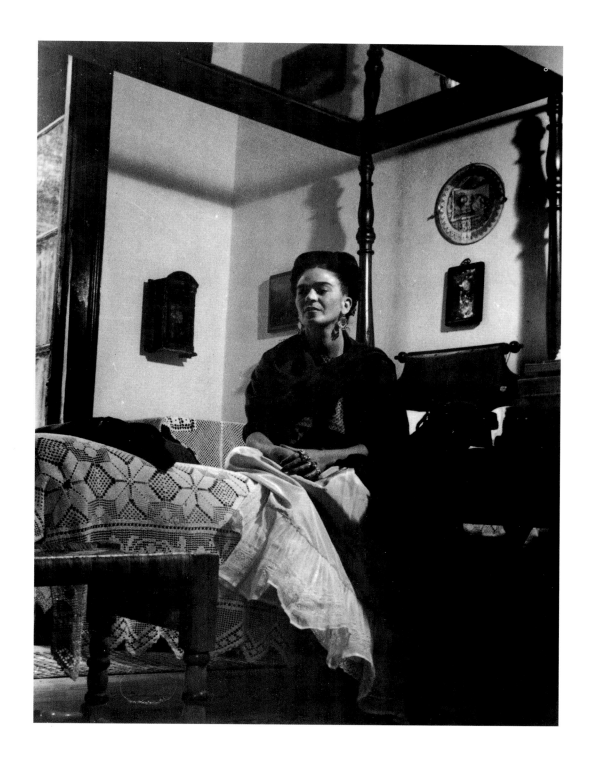

Lola Alvarez Bravo

Mexican, 1907–1993

Frida Kahlo, 1940s

gelatin silver print

© Center for Creative Photography,

The University of Arizona Foundation

No. 18

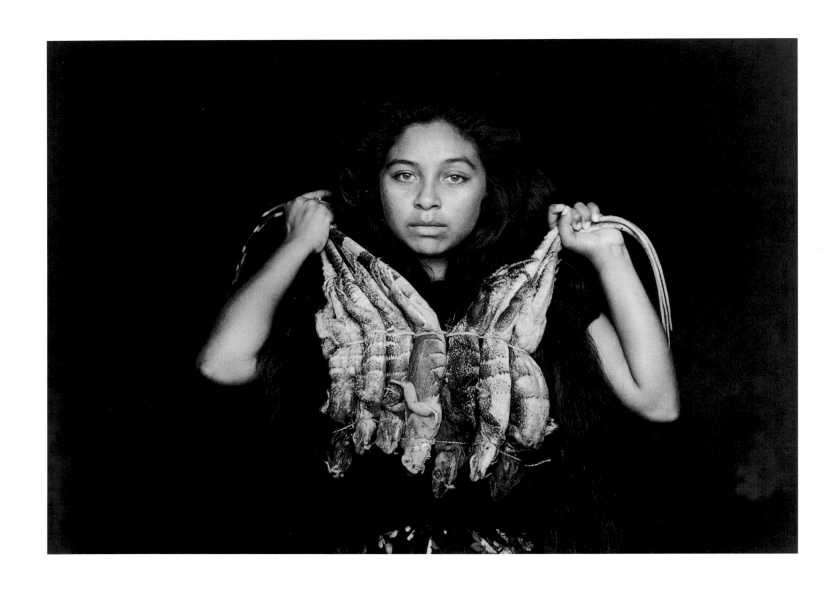

Flor Garduño
Mexican, born 1957
The Woman, 1987
gelatin silver print
No. 19

Although they resemble in formal terms the social survey portraits of August Sander or Thomas Ruff's scrutinizing portrait mappings, Katherine Opie's portraits are created to celebrate the gay and lesbian community. The images are as much about the individual as about a collective or community presence. Her subjects see themselves not framed as the "other" so much as infiltrating the status quo, bringing their community to the forefront. Both Opie and her subjects find it important that the portraits have made their way into museums. Within this framework, the subjects can confront the gaze of the viewer/voyeur. As we stare at them, they stare back, claiming dignity in display and representation.

Opie emphasizes the physiognomy, clothing and expressions of her subjects by isolating the figures in studio settings. Brightly colored backgrounds (inspired by the portraits of Hans Holbein the Younger) further highlight stance, gesture and the line of the body. Opie allows freedom to the subjects in matters of dress, but once in the studio, she manipulates them into position. She does not seek the "essence" of a person but feels that in the process of portrait making, the subjects nevertheless reveal themselves.

Issues of gender and identity are paramount in Opie's portraits. As individuals, her subjects question and subvert traditional gender specifications. *Angela Scheirl* (No. 23) brings to mind August Sander's memorable portrait *Wife of the Painter Peter Abelen* which challenges our expectations of gender identity. As Sander's subject represents the post-World War I "new woman" who is independent, smokes, drinks, wears practical or more comfortable fashions and enjoys increased sexual freedom, Opie's *Angela Scheirl* represents a group of women who have chosen to take back control of their identities, carving new communities and familial structures in society.

August Sander
German, 1876–1964
Wife of the Cologne painter Peter Abelen,
1926
gelatin silver print
The J. Paul Getty Museum, Los Angeles

Another approach to portraiture is that of Lucia Moholy, who transforms her subjects into formal objects. "I photograph people like I do architecture," Moholy said.[9] Her strongest photographs were portraits, although she also produced documentation for the Bauhaus. She was objective and didactic in her approach, bringing out the sculptural qualities of her subjects. Photographing colleagues and friends around the Bauhaus, she worked primarily in close-up to create monumental, intimate portraits. Shooting with a plate camera, she moved systematically from a frontal vantage point, through oblique and three-quarter views, to a profile view, in the manner of architectural photography.

It is apparent that Moholy had good rapport with her subjects. Her portrait of Lita Finsler (No. 24), the wife of the photographer Hans Finsler, depicts a woman who is aware of being photographed and is comfortable with it. Although her images tend to transform her subjects into formal objects, Moholy also successfully captured the human warmth of their individual personalities. Her portraits are neither romantic nor flattering, but the closeness with which she renders her subjects reveals the rapport that she must have had with them.

Not all portraitists seek to define character by focusing on facial features. Dorothea Lange once said " . . . the top of a child's head is the most wonderful place,"[10] recognizing in this feature what seems to be a universal attraction. Ellen Auerbach's sensitive study of her

Mary Ellen Mark
American, born 1940
Tiny, Halloween, 1983
gelatin silver print
No. 20

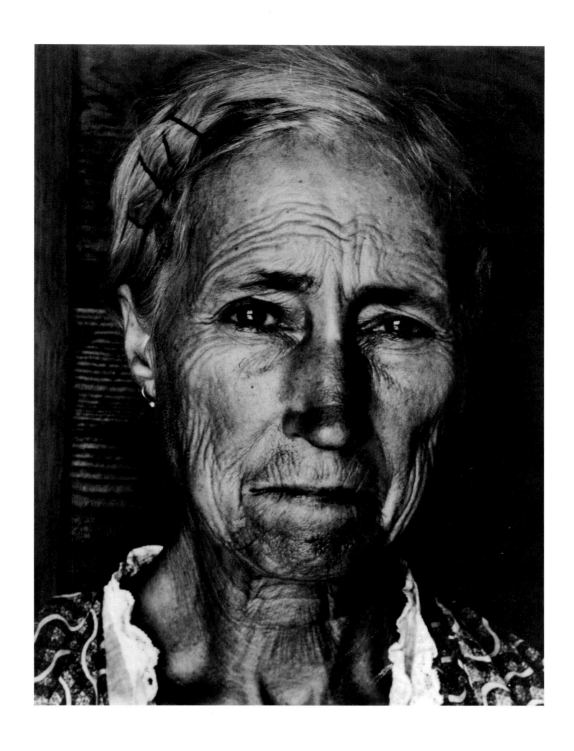

Margaret Bourke-White
American, 1904–1971
Woman, Locket, Georgia, 1936
gelatin silver print
No. 21

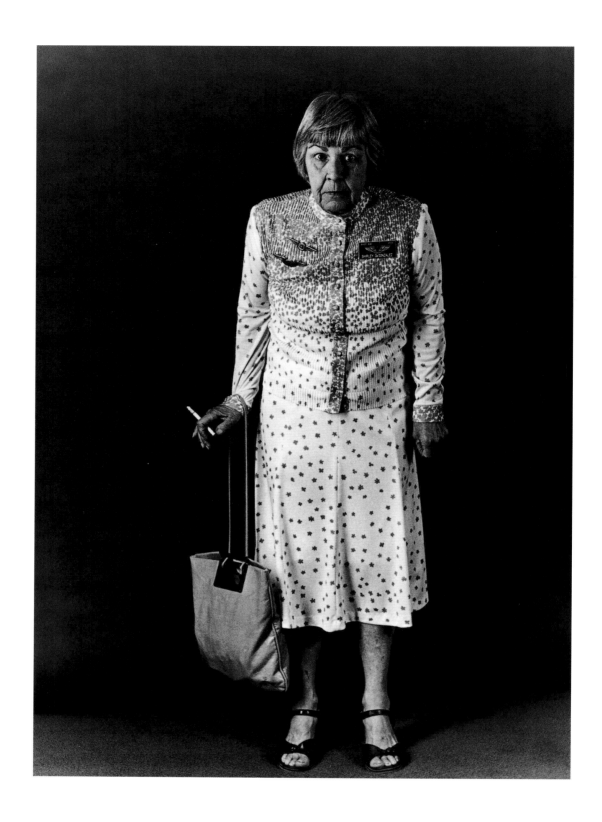

Anne Noggle
American, born 1922
Shirley Condit deGonzales, from the book
For God, Country and the Thrill of It, 1986
gelatin silver print
No. 22

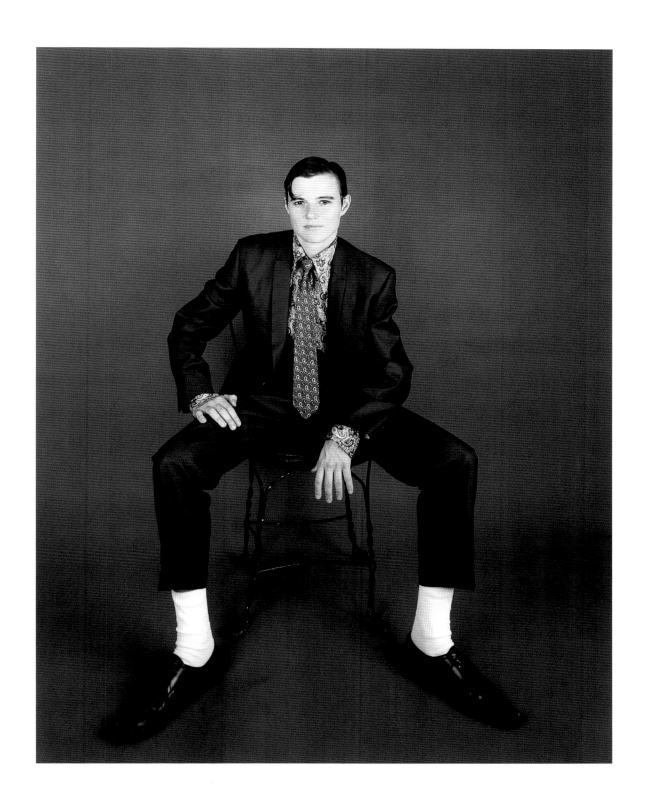

Catherine Opie
American, born 1961
Angela Scheirl, 1993
chromogenic color print
No. 23

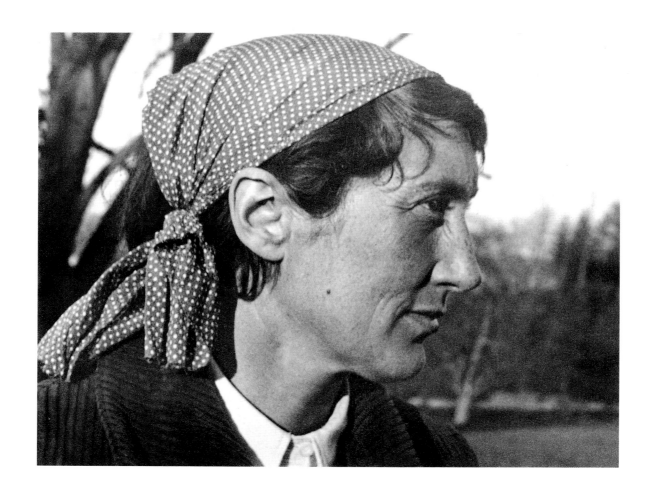

Lucia Moholy
British (born Czechoslovakia), 1894–1989
Frau Finsler, 1926
gelatin silver print
No. 24

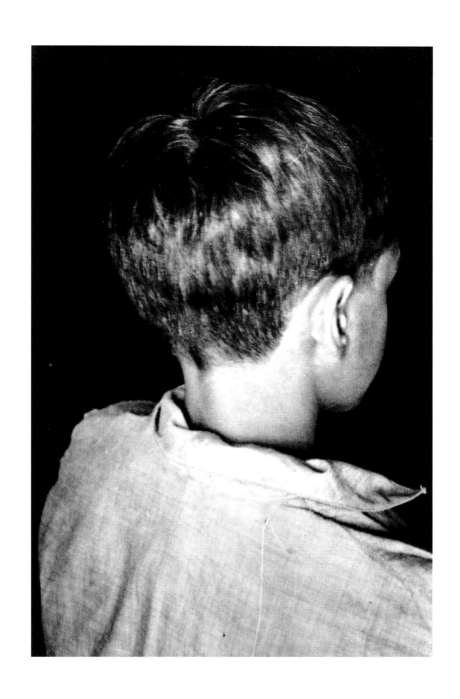

ringl + pit
German
Goggi, 1929
gelatin silver print
No. 25

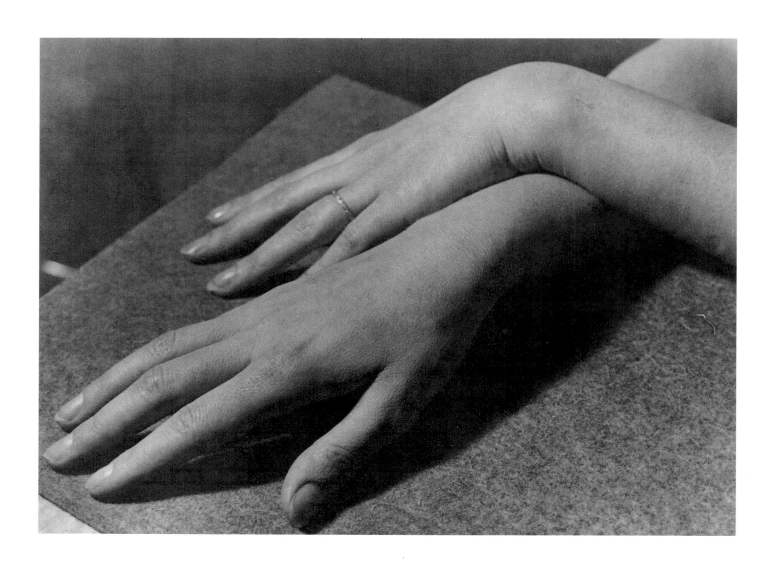

Germaine Krull
French (born Poland), 1897–1985
The Hands of the Actress Jenny Burney, 1928
gelatin silver print
No. 26

brother "Goggi" (No. 25) was made in 1929, the year she met her business partner Grete Stern. In 1930 they founded the collaborative studio ringl + pit where they made portraits in addition to the innovative still-lifes for which they are best known (No. 26). ringl + pit challenged traditional portraiture by using experimental framing techniques like extreme perspectives or tilted camera angles. Like Lucia Moholy, they emphasized the sculptural qualities of their sitters. Auerbach, in her photograph of her brother, creates the effect of a portrait bust, but also invokes a mysterious atmosphere through her use of a dark background.

Germaine Krull, like ringl + pit, creates a symbolic and distilled portrait by isolating one aspect of the sitter's body. A successful photojournalist and commercial photographer in France between the wars, Krull photographed a multitude of subjects ranging from the urban landscape to fashion. Krull explored the optical and structural features of the Eiffel Tower in innovative compositions, but also explored the human body. One such study was her photograph of the hands of the actress Jenny Burney (No. 26). A classic theme in art, hands have often been represented as symbols for the subject's personality or vocation. As much a portrait as an anatomical study, Krull's sensitive rendering of the hands' subtle gestures suggests aspects of the sitter's inner being.

Aya Dorit Cypis is one of a growing number of artists who empower the people they photograph by giving them control over their own representation. She creates interactive portraits by projecting images from the subject's personal archives onto their bodies, and she allows them to pose in response to the images. Cypis then documents these interactions. In this way, the individuals can interpret their own identities. Along with her project, *The Body in the Picture*, of which *Bridget Shields* (No. 27) is a part, Cypis has also developed an interactive program called Kulture Klub for inner city homeless and at-risk youth which provides an outlet for creative expression in collaboration with visiting artists. In her multimedia work, Cypis illustrates the many cultural and social influences that make up individual identities.

Central to the Modernist aesthetic, the search for epiphanies in everyday objects and events and in the actions of people seems still to be a valid exercise, particularly when linked to self-investigation and self-knowledge. An action, gesture or exchange between two individuals can mark a sense of grace which reveals the inner life of the photographer and inspires the viewer's own personal associations. Margrethe Mather, Debbie Fleming Caffery, Annie Liebovitz and Nan Goldin have all made portraits that have recorded private moments in which their subjects are lost in reverie. In such a state of contemplation, a subject is both object of the gaze and in control of a world the viewer will never experience. The acknowledgment of introspection, of private and independent thoughts, confounds the viewer's participation in the scene. Daydreams are a form of escape; for women they are often the repositories of desire, longing and prohibited activity. These journeys are avenues of power through which the protagonist may seek and fulfill goals.

Margrethe Mather, assistant and later manager of Edward Weston's studio in Glendale, California, captured such a moment of grace in her portrait of Buffie Johnson (No. 28). Mather, who has been credited with lending direction to Edward Weston's early vision, had

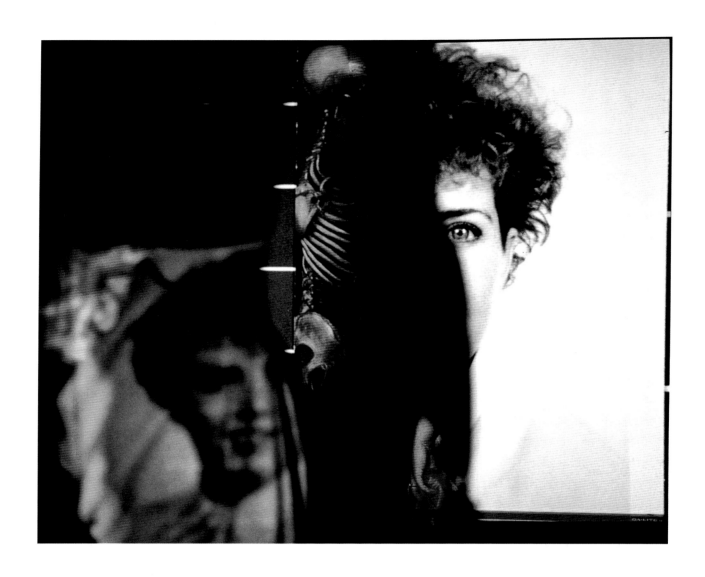

1. Bridget Shields
2. Bridget, age 17, 1984
3. From the 19th century painting "La Belle Rosine"

Aya Dorit Cypis

American, born 1951

The Body in the Picture: Bridget Shields, 1993

chromogenic color print

No. 27

a sophisticated understanding of the composition of space and form. She worked both in the studio and outdoors and enjoyed the results produced with natural light. She subsisted on portrait commissions from socialites and Hollywood personalities and was known for her quality work. As a young art student at UCLA, Johnson heard from a friend that the photographer needed money and, having funds at the time, she arranged to have her portrait made.[11] Taken on a hilltop, Mather's portrait of the young painter is an example of her masterful sense of graphic design. Although the photograph is closely cropped, the dynamic angle at which Johnson's head is placed in the frame and the model's expression gives the composition a sense of lightness. Masterful, too, is Mather's attention to pattern as she echoes the sitter's spotted collar with blurred, sun-dappled trees. Mather's intimate portrait of Johnson becomes a sensual study of introspection.

Debbie Fleming Caffery's expressive use of photography accentuates states of grace that can be found in the known world. She seeks out the unbridled magic in the Louisiana landscape which is saturated with a rich and complex layering of history, memory, dream and archetype. Caffery works in the middle to dark ranges of the medium's capabilities, rendering deep bass tones of black on black or gray on black. Even the sun shines darkly. Epiphanies are at the heart of Caffery's images, and in *Praying* (No. 29) we clearly feel the woman's intensity. Caffery's images are like spirituals sung with an emotion that borders on madness. These are not objective documents, but poetic pictures that tell stories of adversity, hard work, determination and courage.

Annie Leibovitz's candid photograph of the late Jerry Garcia (No. 30) presents another aspect of introspection. As an editorial portraitist, Leibovitz specializes in creating photographs which directly express the character of the subject. Different from her many staged portraits, this view of Jerry Garcia is refreshingly spontaneous and poignant. The photograph, one of several portraits of the musician in the collection, is one of Kornblum's favorites because unlike the others, it is a candid photograph that reveals Garcia's introspection in terms of his dedication to his music.

Nan Goldin has spent her career documenting her life and the lives of her friends, letting the viewer observe intimate moments as an invited voyeur. Her closeness with her subjects makes the act of photographing almost invisible. Often family and friends go about their lives as if the camera did not exist. Rendering scenes as rich as a medieval tableau, Goldin opens her self to us like a patient on an operating table. We are invited not only to partake of a unique family album but to participate, to regard those images as if they were images of *ourselves*. It is not the experiences of Goldin's subjects as much as their emotions that we share, making us both observers and participants. Immersed in the life of "the other," we are drawn in by the generosity of intimacy. In addition, the large scale of Goldin's photographs seductively invites us to enter the scene.

Gina at Bruce's Dinner Party (No. 31), a record of intimacy and introspection, is also a reference to image-making, rich with art-historical references. The "still-life" with fruit on the table and the reproduction on the wall underscore the fact that we are looking at a

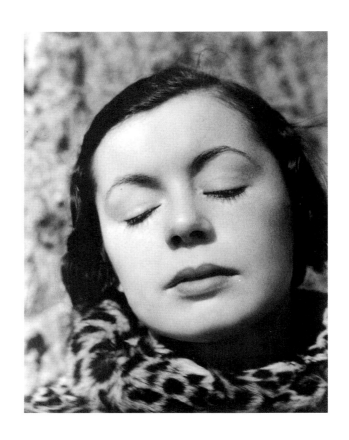

Margrethe Mather
American, 1885–1952
Buffie Johnson, Painter, 1933
gelatin silver print
No. 28

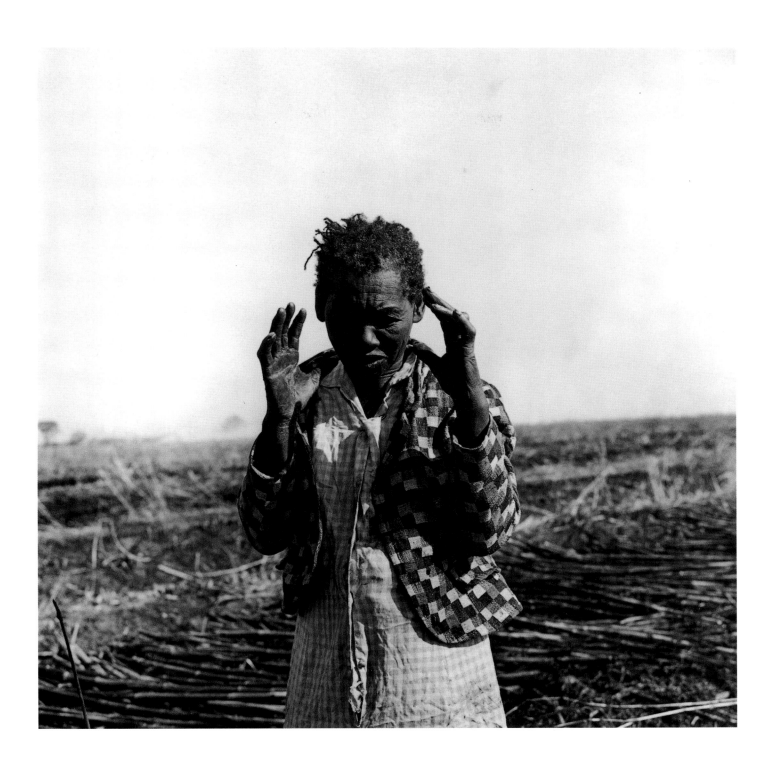

Debbie Fleming Caffery

American, born 1948

Praying, 1976

gelatin silver print

No. 29

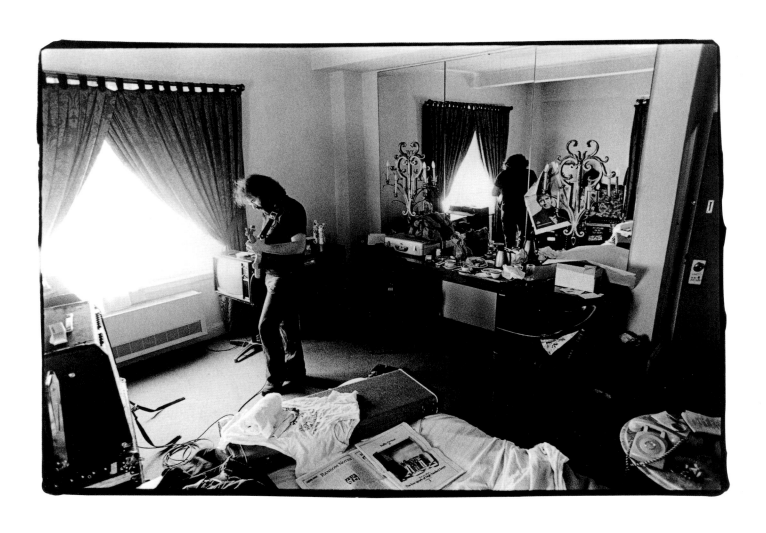

Annie Leibovitz
American, born 1949
Jerry Garcia, NYC, 1973
gelatin silver print
No. 30

56

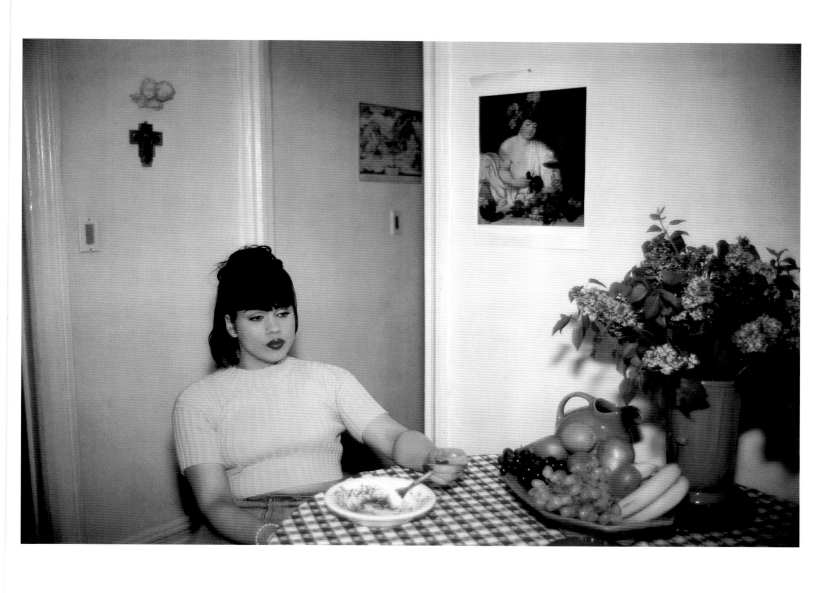

Nan Goldin
American, born 1953
Gina at Bruce's Dinner Party, NYC, 1991
silver dye bleach print
No. 31

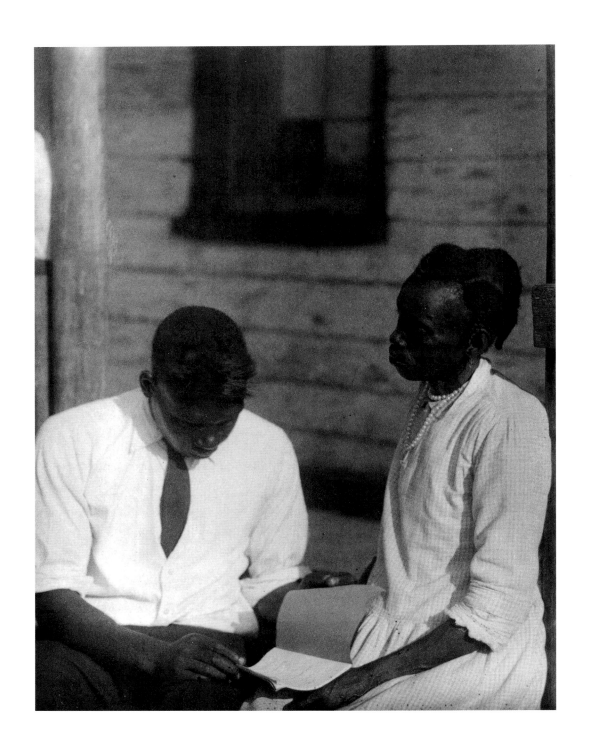

Doris Ulmann

American, 1882–1934

South Carolina, 1929

platinum print

No. 32

representation. Often compared to artists like Caravaggio or Vermeer, Goldin creates her own "Old Master" images by melding saturated and seductive color with allusions to timeless and universal emotions.

The Human Bond

Human relationships form the foundation of social and cultural structure. The complexities of these relations form a core group of images in Kornblum's collection. By vocation and disposition, she is drawn to images that show individual psychological struggles or investigate human relations.

Although Nan Goldin traces emotions in a select stratum of society, we can relate precisely because her photographs offer insight into the complexities of human interactions. A photograph, in its act of freezing time, is able to record transient gestures and facial expressions that reveal the intricacies of human relations. Moments like these bring to mind passages from Virginia Woolf's *To the Lighthouse* where inner relations between people are articulated. Nell Dorr, Doris Ulmann and Barbara Norfleet also record such passing spirits.

In contrast, a generation of artists in the 1980s, including Tina Barney, Carrie Mae Weems, Sandy Skoglund and Eileen Cowin, constructed scenes which forcefully illustrate the foundations of human relations. They question photography's apparent veracity, and address issues of race, gender and representation directly. Whether by chance in the documentary photographs of Barbara Norfleet, or by design in the constructed tableaux of Cowin or Skoglund, the subtle or overt gestures which delineate social structure and the link to their environment are defined. Images that deal with a woman's experience are manifest.

Nell Dorr's personal tragedy, the death of her daughter, compelled her to make the relationship between mother and child the focus of a photographic series. A celebration of motherhood, the resulting images emphasize the closeness and physicality of this relationship. Unlike the Arbus photograph of the mother and child discussed earlier, Dorr's image (No. 33) is an archetypal representation. A heightened sense of the spiritual emanates from the two as they embrace. Dorr believed in a mystical bond between mother and child, and to represent this idea she uses compositional devices that stem from age-old systems of visual expression. Hers was a poetic investigation driven by a belief in mystical sources and theological goals.

A similar mystical bond is illustrated in the image of an old woman and a young man from Doris Ulmann's study of African-American plantation workers in South Carolina (No. 32). The photograph, like others from the series, expresses neither social commentary nor detached rationalism. The softened focus is drawn from Pictorialist conventions; like Caffery's photographs, Ulmann's prints become expressive evocations of a very personal point of view.

Opening a glimpse into the microcosm of American upper-class life, Barbara Norfleet was an outsider who was able to move easily among the world of the elite. Her photograph of

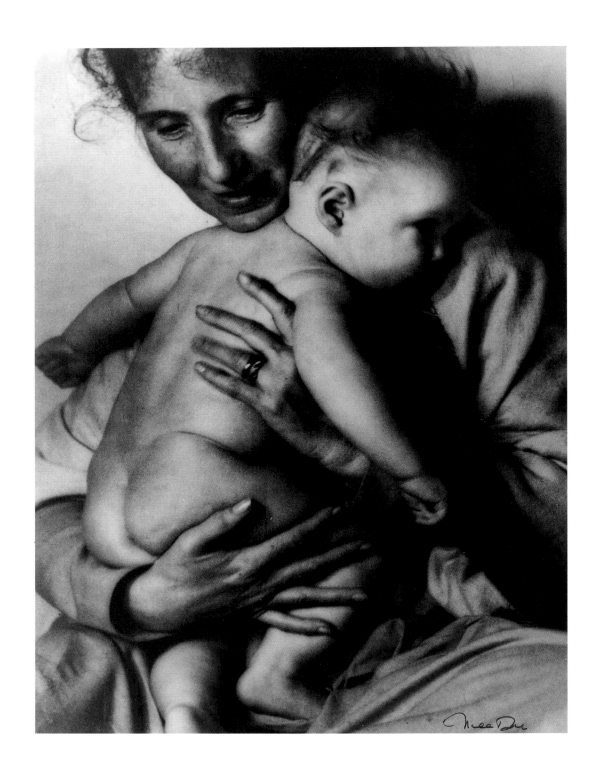

Nell Dorr

American, 1893/5–1988

Mother and Child (Happiness), 1940s

gelatin silver print

No. 33

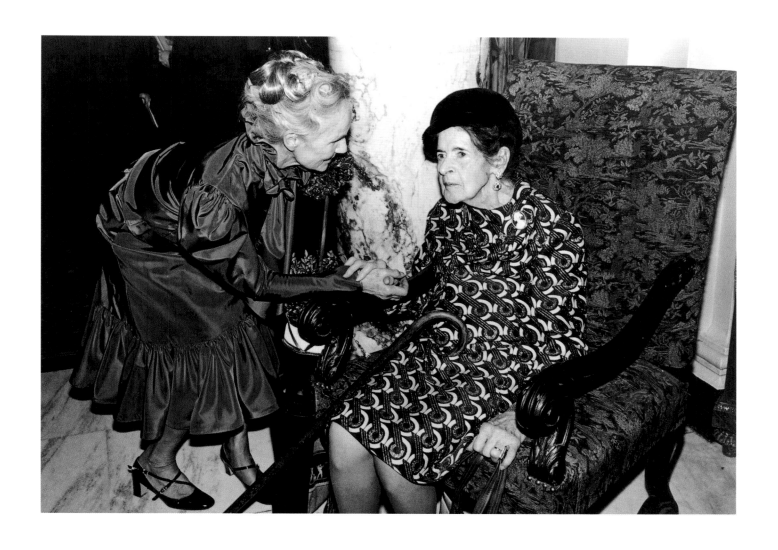

Barbara Norfleet
American, born 1926
*Benefit for the Mount Vernon Ladies Association of
the Union, Copley Plaza Hotel, Boston, Massachusetts,*
from the book *All the Right People*, 1983
gelatin silver print
No. 34

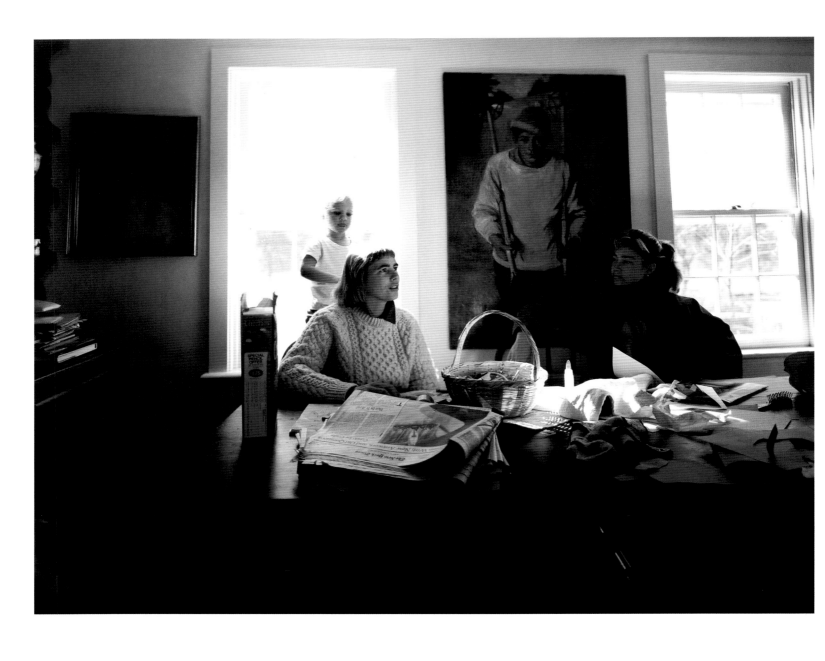

Tina Barney
American, born 1945
The Skier, 1987
chromogenic color print
No. 35

two women at a Ladies Association benefit (No. 34) speaks of aging, the relentless movement of time, and its lack of discrimination or preference in the people it touches. Sustained only by a reassuring touch, the elderly woman in the chair provides a reminder that wealth is no protection against the vulnerabilities of age.

The intricacies of emotions and their effect on interpersonal relationships are investigated through alternative means in the works of Tina Barney, Sandy Skoglund, Holly Roberts, Annette Messager and Eileen Cowin. These artists, who construct rather than find their scenes, rely as much on interpretations that the viewer brings to the work as they do their own expression of ideas. While the opinions are strident, the images present a layering of meaning that keeps them from being didactic.

Tina Barney's society photographs are carefully staged pseudo-documentary tableaux which mimic candid photographs. Like Norfleet, Barney is concerned with documenting a way of life that most of us can just imagine. Barney's carefully frozen images from life depict moments of quotidian significance. In *The Skier* (No. 35), we view the instant between two significant moments when expectation is at its peak. This photograph is not about connections between people, but about the individual worlds in which they live. Although confined by common space, the people in the photograph *at that moment* are each encompassed by their own marked interiority. It is ironic and telling that only the subject in the painting meets our gaze. Barney's photographs present carefully orchestrated, artificial aspects of the American Dream. They challenge our ideas about the veracity of photography while simultaneously questioning the values inherent in the scenes depicted. The American Dream is as constructed as Barney's photographs.

Artificiality is a central device for Sandy Skoglund. She uses surrealist tactics to evoke a multitude of interpretations. Her images often pit nature against culture, along with a layering of other issues, particularly relations between people. The people she chooses to describe are the products of suburban or urban society. Just how they relate to their environment is underscored through her use of artificial animals, mannequins, and other props. By exploiting photography's innate "truth," Skoglund's images become fantastic records of a suggested reality.

Skoglund's photograph *Atomic Love* (No. 36) appears to be a domestic scene and suggests an extended family tableau. However, only two of the figures are not mannequins. In various states of frozen animation, the mannequins seem to occupy their own world or pose in reaction to the two human beings in the room. Skoglund's use of these mannequins and the monochromatic environment suggest alienation and the absence of any human interaction. Psychologically ambiguous, the image is made more so by Skoglund's application of thousands of raisins to the walls, figures and props. This pointillist game adds yet another level of symbolism to the mix. Literally blending into the background, the figures have become or are becoming inanimate objects within their environment. These issues are very pertinent in view of today's computer-mediated interactions between people. In addition to our alienation from the natural world, we also face an estrangement from human interactions.

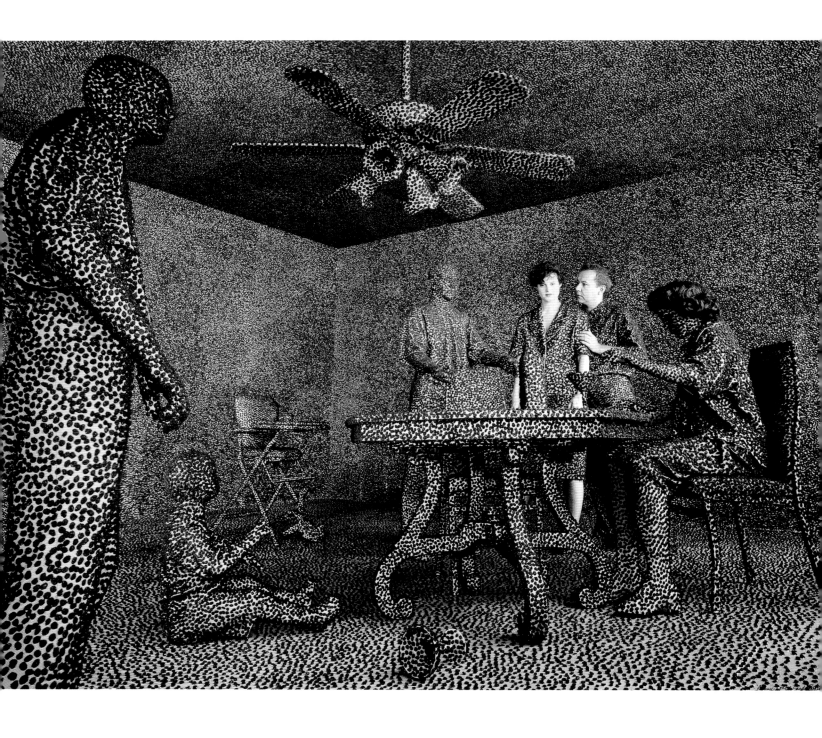

Sandy Skoglund
American, born 1946
Atomic Love, 1992
silver dye bleach print
No. 36

Holly Roberts, who obscures the greater part of her photographs by painting over them, frequently addresses the tensions within male-female relationships. By painting another figure directly over its photographic counterpart, Roberts often creates alter-egos which disclose multi-level personas. She exploits the surreal shift that occurs when the photographic image emerges from beneath the painted surface. The interplay between the real and the fictive results in an image that can be experienced on a number of psychic levels. In blending myth and dream, Roberts draws from the iconography of the Native American, Mexican and Hispanic cultures of the Southwest where she resides. Using marks that suggest petroglyphs and pictographs, Roberts exploits the elemental nature of such images. In *Sad Woman/Angry Man* (No. 37), a superimposed two-faced figure refers not only to the complications of male-female relations but also to the anima/animus conflicts within each of us. The direct gaze of the underlying figure helps underscore the bond between the viewer and the psychic elements of the image.

Annette Messager often works with materials that are traditionally "feminine," like stitchery and knitting, to challenge our notions of gender bias. She combines found objects and images with text to create sculptural works which address issues of femininity, identity, and interpersonal relationships. In *Possession* (No. 38), Messager combines a confrontational photograph with text and crewel embroidery. At the center of the repeatedly stitched word "Possession," which creates an "X" across the cloth, is a small black and white photograph of an open mouth. In her series *mes ouvrages* (my work), she combined a selection of words like *promesse*, *mensonge*, *soumission*, *tentation* (promise, lie, surrender, temptation) with photographs of body fragments. These image/word combinations are a reminder of the psychological intricacies and pitfalls of human interactions and the way in which the body and mind are affected by them.

Since the 1970s, Eileen Cowin has created images that blend *film noir*, art historical references, psychological and philosophical theories, and the dramaturgy of daytime television in elegant tableaux. In the past ten years her work has become less specific and more universal in its narrative content. She engages the viewer in a film-like experience, using a dark background and subtly highlighted subjects to draw the spectator into the scene. The richness and resonance of her subjects reveal the tensions in everyday relationships. Cowin's open-ended scenarios deal with universal desires, fear, alienation, aging, loss and change.

Untitled (Dripping Hands/Praying Mantis) (No. 39), from *Landmines*, is a series inspired by a remark in which Milan Kundera outlined the transaction of cause and effect in the events of everyday life.[12] These episodes, which can become monumental, he called "landmines." Cowin herself stumbled upon a "landmine" in 1994 when she awoke to the tremors of the great Los Angeles earthquake which destroyed her home and studio. This experience gave her the "authenticity" to continue the project. In response to this event, she drew from epic stories of plagues of locusts from biblical sources or the eruption of Mount Vesuvius in Pompeii.

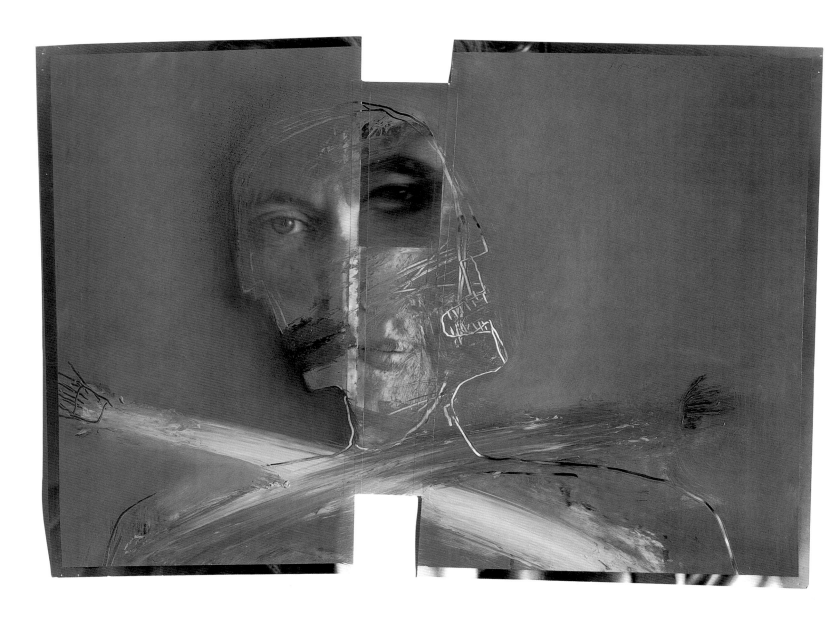

Holly Roberts

American, born 1951

Sad Woman/Angry Man, 1992

oil on gelatin silver print

No. 37

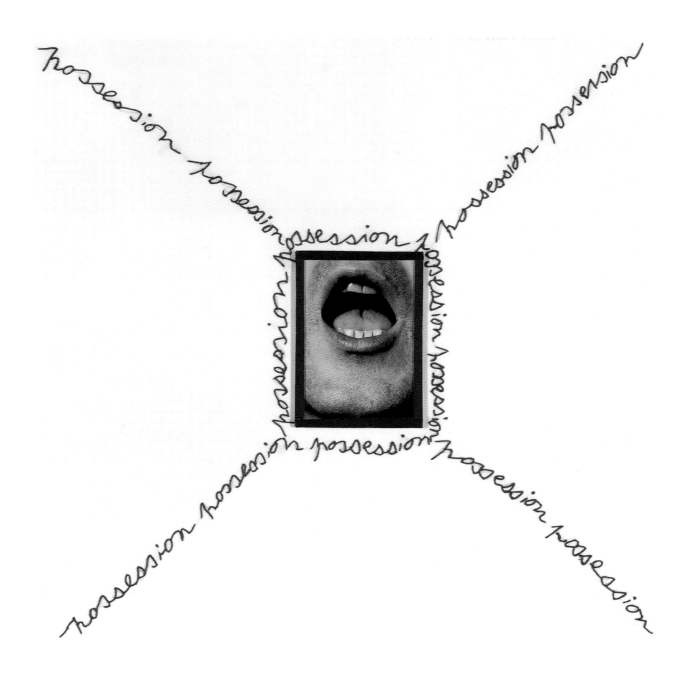

Annette Messager
French, born 1943
Possession, from the series, *Mes Ouvrages*, 1989
gelatin silver print and mixed media
No. 38

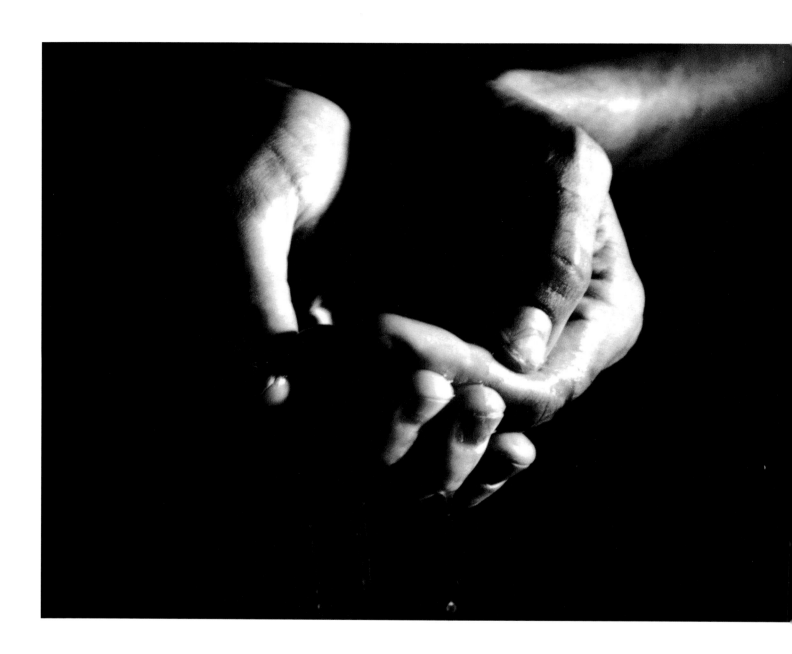

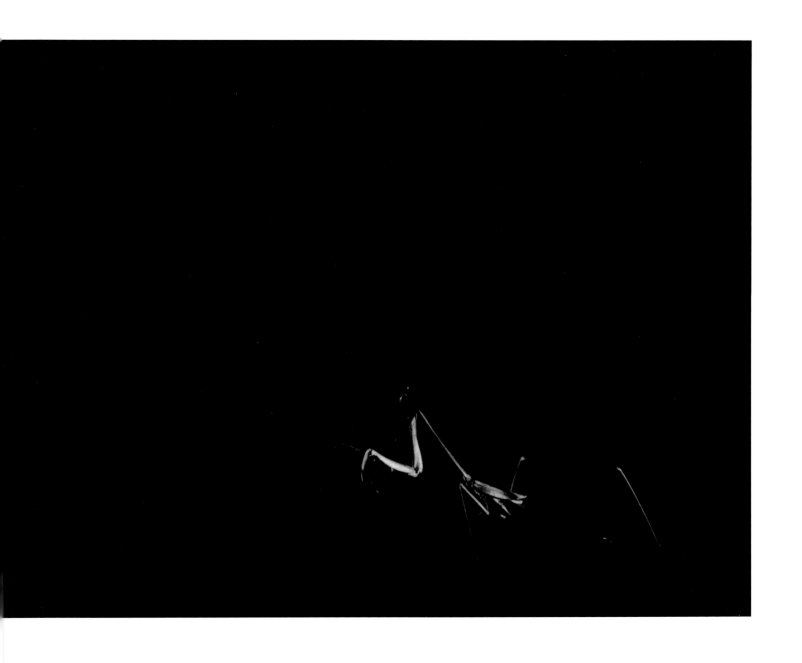

Eileen Cowin
American, born 1947
Untitled (Dripping Hands, Praying Mantis), 1994
gelatin silver print
No. 39

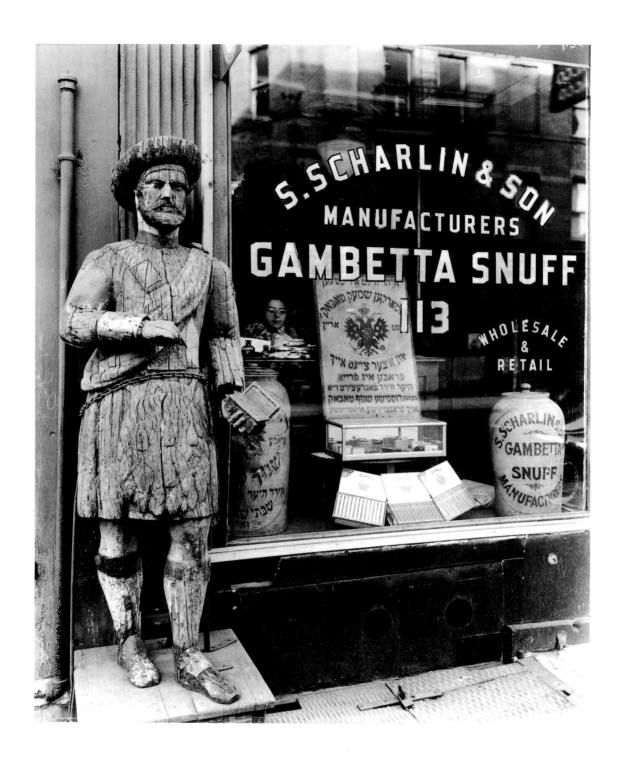

Berenice Abbott

American, 1898–1991

Gambetta Snuff Shop, NYC, 1935

gelatin silver print

© Berenice Abbott/Commerce Graphics, Ltd.

No. 40

Kundera's statement brings to mind the relationships outlined by a modern concept called chaos theory; in simple terms chaos theory has been described as an understanding of how things interact. For example, a butterfly beating its wings in Argentina can affect the weather in our home town simply because it sets off a chain of unpredictable relationships of cause and effect. Although it is labeled the "chaos theory," it is far from chaotic. It exposes a complex and fragile network of relationships that on their own seem trivial, but within the context of the whole hold immense weight.

Place and Space

The understanding of one's place within society helps define the self. However, the construction of self is also affected by the environment in which one lives. The experience of place and space, both public and private, is affected by a complex combination of socially and culturally constructed images which help define our place in the world. Photographers have always recorded the world around them in order to create a sense of place. In the 19th and early 20th centuries, photographers like Francis Frith, Eadweard Muybridge and Eugène Atget helped create a sense of place by recording the landscape and the urban environment. In doing so, some also perpetuated mythologies about power and vista, creating a hierarchical relationship of man over nature, and Western man over indigenous cultures.

The women photographers in this collection who deal with place and space proceed in an intimate way; they find meaning in liaisons among objects, place, history and memory. While Dorothy Norman's view of Alfred Stieglitz's gallery is about memory, loss and absence, and Berenice Abbott's New York photographs record a city poised on the edge of change, Candida Höfer reveals the alienation within public spaces. Uta Barth investigates the qualities of presence and absence in space and how it is affected by visual perception. Barbara Ess internalizes space and place, finding metaphors for the space which is occupied by an inner existence. Joan Myers, Meridel Rubenstein and Martha Rosler call attention to the effects of war on human life and the land. Collectively, these artists define the world as well as themselves by acknowledging the importance of their relationship to their environments.

Berenice Abbott recorded absence, presence and flux in her series *Changing New York*, which was made with the support of the Works Progress Administration (WPA). After returning from Paris in 1929, where she had been assistant to the Surrealist Man Ray, Abbott's relation to New York shifted and she saw the city with "fresh eyes." Like Eugène Atget, whose photographs of Paris she had discovered earlier, she wanted to record New York before it changed completely. Abbott's photographs of the city are silent, sculptural and usually devoid of people.

In Abbott's work, presence is depicted in the *traces* of human existence: shop windows displaying goods on the verge of use, empty rooms with evidence of habitation, and buildings that appear monolithic but occupied. If we examine these photographs closely, we find people residing in or passing through the picture plane. In *Gambetta Snuff Shop, NYC* (No. 40) we find a child, almost hidden by the large wooden Scotsman outside, peering from the window of the shop. This subtle detail drew Kornblum to the image because the child added a

human element to an otherwise formal photograph. It is interesting to note that the text Abbott prepared for *Changing New York* adds human animation to her otherwise quiet images. In *Snuff Shop*, she relates the "adventures" of the cigar-store Indian, a "Scotch Indian" named Sandy. By animating the figure through anecdotal text, Abbott injects a note of humanity and humor into the scene.

The images Dorothy Norman made of Alfred Stieglitz's last gallery, An American Place, evoked her loving memory of the place and the inspiration it provided. Quiet and meditative, the prints reflect her reverence for the idea of the gallery, which was to be a "laboratory center" for the free exchange of ideas.[13] Made after Stieglitz's death in 1946, *Walls, An American Place* (No. 41) suggests absence and loss. The shafts of light seem an elegiac reference to Stieglitz and his lifelong fascination with light. Light has the ability to create space from nothingness, to form the elemental structure of things both tangible and intangible. This photograph speaks to Norman's interest in expressing the idea of the infinite in her intimate photographs, and her feeling that art and photography could offer society a holistic experience.

Candida Höfer's images of empty public spaces speak of alienation. Impersonal spaces supposedly designed for everyone withhold any capacity for anyone as an individual; in fact, they are what could be termed "placeless." The photograph *Schloss, Weimar* (No. 42) is evidence that even within the confines of the elitist of spaces, the palace, the democratic order has taken hold. Such oversized, disproportionately inhuman spaces were once reserved for the smallest section of the population. Now they belong to the people and function as spectacles, places to experience but not to possess.

Waiting rooms, museums, restaurants, courtrooms, libraries and classrooms are all subject to Höfer's analytic documentation. Seemingly devoid of human content at first, these photographs usually reveal a suggestion of occupation. In *Schloss, Weimar*, chairs, which are themselves powerful symbols for human beings, are the sole indicators of a human purpose or presence. The rigorous formal arrangement and repetition in these images underscore the order of social life that such public places perpetuate. Höfer reveals the irony of how these "public" spaces can be so inhuman.

The viewer is primary in the experience of the spaces that Uta Barth chooses to record. Her images rely on the interaction among the viewer, the photograph and the space the photograph occupies. Barth's photographs record spaces that were once occupied, defining an environment outside traditional experience. A very photographic construct which is made possible by the optical capabilities of the camera—depth of field, focus and framing—the images are photographs of negative space. This conceptual investigation of photographic seeing shifts our understanding of place and space. Firmly grounded in the material world, we seldom think in terms of "in between." We map our paths from one solid object to another.

Barth has created two series: *Field* and *Ground*. Images from the *Field* series were taken outside; *Ground #57* (No. 43) inside. Each presents a view of the solid and the intangible as they relate to one another. An awareness of "image" as constructed is also inherent. Barth

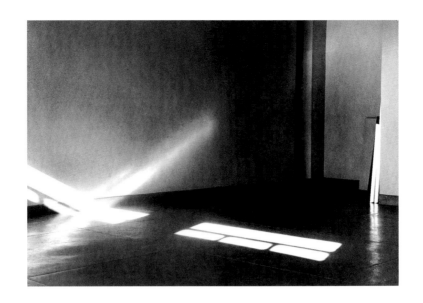

Dorothy Norman
American, 1905–1997
Walls, An American Place, 1940s
gelatin silver print
No. 41

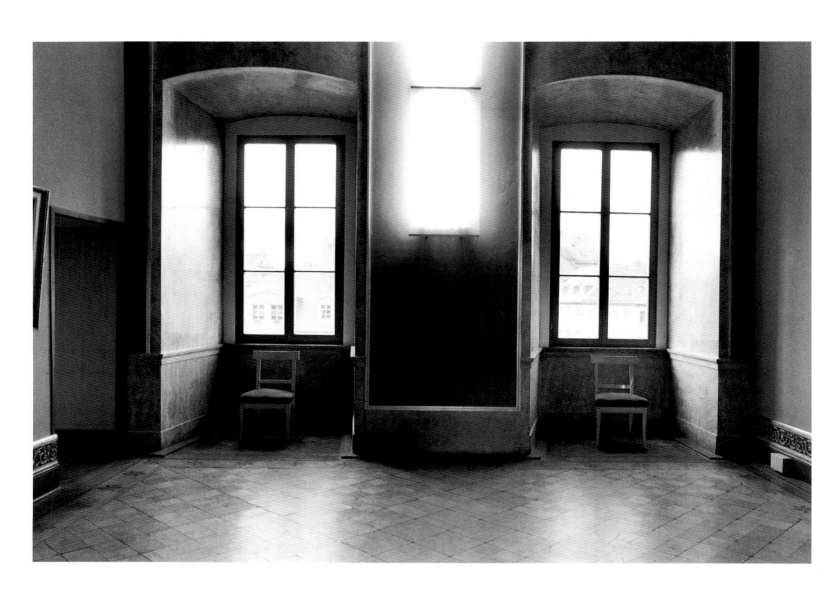

Candida Höfer
German, born 1944
Schloss, Weimar, 1991
chromogenic color print
No. 42

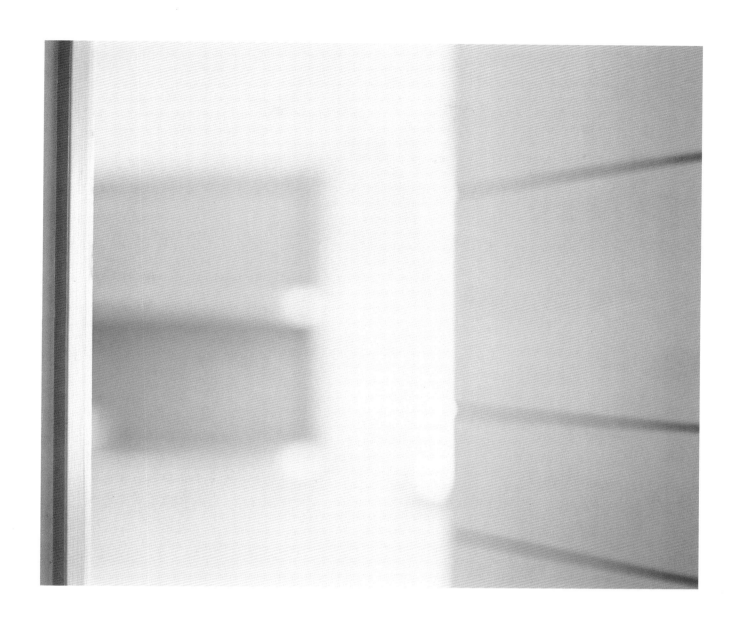

Uta Barth
American, born Germany 1958
Ground #57, 1994
chromogenic color print
No. 43

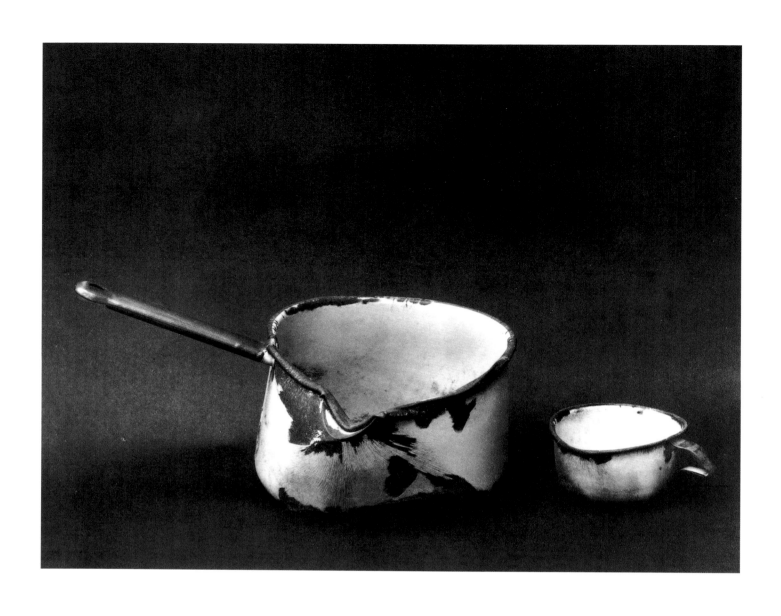

Joan Myers

American, born 1944

Pan and Cup, from the *Japanese Camp* series, 1984

gelatin silver print

No. 44

refers to the conventions of picturemaking not only in the titles of her series, ("Field" and "Ground" both suggest a painting's boundaries and its surface), but also in her attention to the work's position during its exhibition. Here, the context for the work and the work itself are in dialogue. Barth often plays the optical interpretations of space against the spaces themselves. For example, she juxtaposes image against reality by installing a photograph of the corner of a gallery wall on the same corner. Aware of art-historical traditions, Barth refers to Vermeer's spatial constructions as relevant to her work. As is evident in *Ground #57*, she is similarly interested in the formal arrangement of interior planes and the luminosity of light, paring out details to leave only the essence. In Vermeer's work, the domestic scene is energized by a human presence, often in a state of expectant hesitation. That waiting moment, similar to the one Tina Barney records in *The Skier* (see No. 35), is presented in Barth's work as absence. It is this absence which creates a feeling of heightened expectation and a hint of presence.

Joan Myers is also a recorder of absence in her series on Japanese internment camps. In her images, absence refers to historical events which linger as memory in objects, empty buildings and truncated foundations. Myers came across the site of a Japanese "relocation center" at Manzanar, California while on a family vacation that took her through the Mojave Desert. She photographed the landscape: the ground littered with broken buildings and dead gardens. She found remnants of life filtered through objects left behind by the land's former inhabitants. Ordinary household objects like fragments of china, a flyswatter, cutlery, pots and pans, and a toy car could relate a multitude of stories. Half rotten, chipped, and the color of earth, they were beginning to work their way back into the land. Theirs is the patina of history and use.

Pan and Cup (No. 44) refers to domestic life within the confines of a camp. The chipped enamel pots signal an existence made destitute through the forces of politics. Gary Y. Okihiro, author of the text for Myer's book *Whispered Silences: Japanese Americans and World War II* relates the stories of hardship faced by the internees. These were people, respected in their past communities, who had been uprooted from their homes and forced into what Okihiro describes as concentration camps. Myers wanted to create a heightened awareness of this disgraceful aspect of American history. The abandoned buildings and scattered objects portray an obvious sense of absence, but it is an absence that speaks forcefully through Myers' images: of resilient life and death and heartache.

Martha Rosler utilized montage to underscore her reaction to the images of war on television and in print in her series *Bringing the War Home (House Beautiful)* (No. 45). In these constructions, she uses idealized images of the home (a construct in itself) in juxtaposition with photographs depicting the ravages of war, thus drawing attention to what she feels is society's alienation and isolation from the realities of war. Rosler appropriated photographs from mainstream magazines such as *LIFE* and *House Beautiful* to question our involvement with the very real social and economic effects of war and, at the same time, to question our comfortable domestic existence. Within this context, our relationship to place and space, both domestic and social, is addressed. Like Barbara Kruger or Sandy Skoglund, Rosler

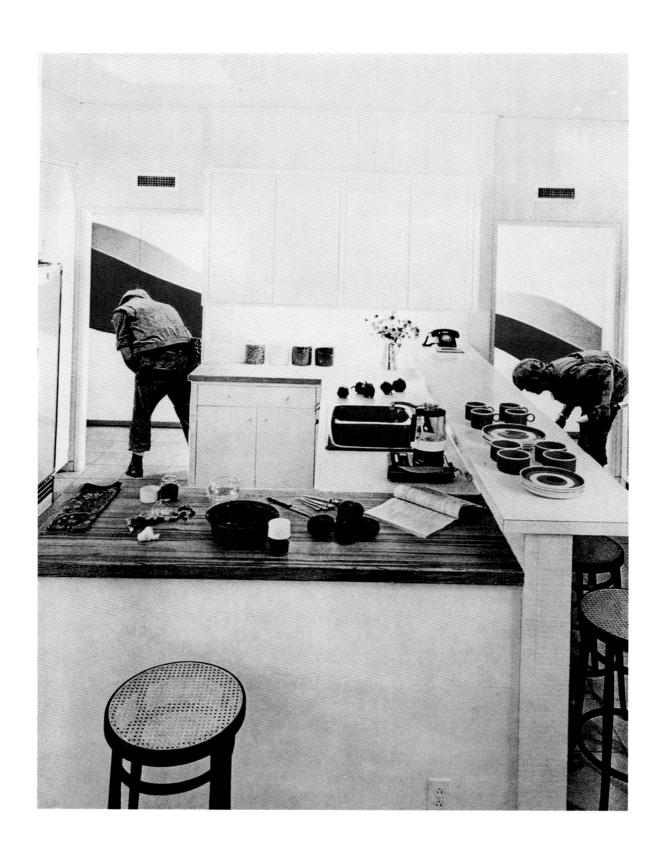

Martha Rosler
American, born 1943
Red Stripe Kitchen, from the series, *Bringing the
War Home: House Beautiful,* c.1969–72
chromogenic color print
No. 45

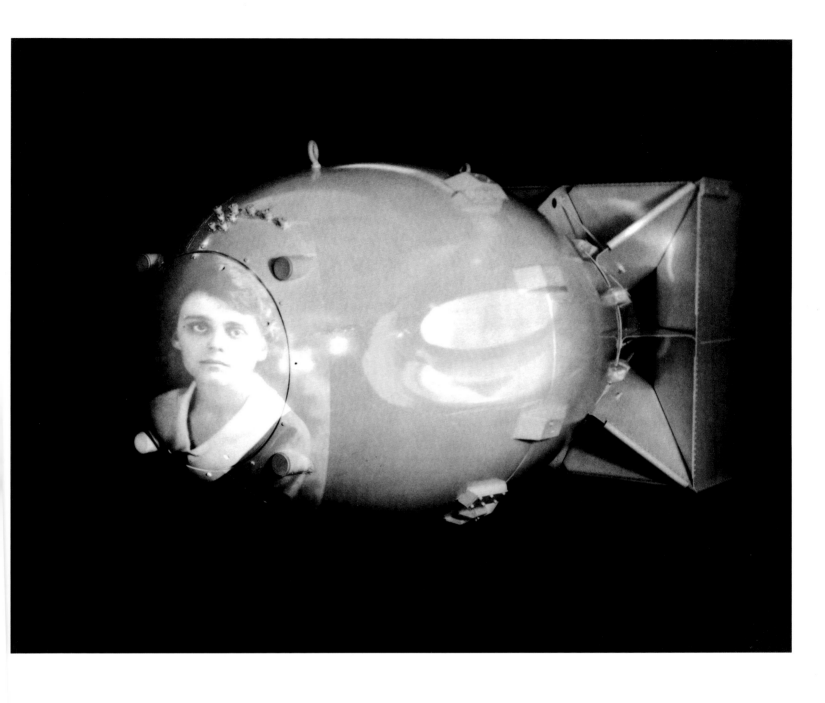

Meridel Rubenstein
American, born 1948
Fatman with Edith, 1993
palladium print
No. 46

Barbara Ess
American, born 1948
Untitled, 1995
chromogenic color print
No. 47

manipulates the medium to confront photography's own frailty in the representation of "truth." By subverting the image through the collage of incongruous scenes, she exposes the fragile boundaries of the medium. Rosler's message is direct and to the point—the images have an immediacy that is instantly readable.

Meridel Rubenstein addresses another aspect of the human effects of war in her multimedia project, *Critical Mass. Fatman with Edith* (No. 46) is a photowork from *Critical Mass*, a project conceived by Rubenstein in collaboration with performance artist Ellen Zweig and video artists Steina and Woody Vasulka. *Critical Mass* examines the connections between the San Ildefonso Pueblo people, the participants in the Manhattan Project, and Edith Warner. Warner, who lived in the Pajarito Plateau area of New Mexico near the site of the Manhattan Project's base, created a refuge at her home for the participants. To escape the intensity and secrecy of life on the Manhattan Project (the site where the first atomic bomb was developed), the physicists would gather at Warner's home for discussion and dinner. Warner's partner, the former governor of San Ildefonso, formed the connection to the Pueblo people and through this alliance formed a bridge across cultures.

Rubenstein's complex project touches on issues of domesticity, the crossing of disparate cultures, the establishment of a sense of place and human response to war-related activity. In this regard, *Fatman with Edith* is not merely a "portrait" of Edith Warner, but also a statement about how historic events affect the lives of ordinary people. And there are numerous other layers of meaning. One unexpected interpretation comes in the nature of the bomb itself. Because the laws of nature were harnessed to create the bomb, cultural anthropologist Hugh Gusterson, who participated in a symposium on the *Critical Mass* project, pointed out that "The bomb became a symbol of the secrets of nature and infinite power."[14] The bomb's terrible beauty is at once in the spectacle, the mathematical formulas, and the process itself, which, for the scientists, was part of the project's attraction. Likened to an egg, a breast, or a phallic symbol, the shape of the "Fatman" bomb triggers another array of meanings.[15] However, the ultimate effect of the bomb continues to dominate our understanding of our place in the cosmos by shifting our concepts of power, scale and beauty, an indelicate balance that Rubenstein underscores in this complex work.

Like Eileen Cowin, Barbara Ess creates images that resemble film stills, although her "stills" seem to be extracted from what would fall between grounded moments in a narrative. In a film, these would be the blurred sections that could support subliminal messages. Utilizing a pinhole camera, Ess exploits the camera's capability to render alternate realities. The distortions, vignetting, and heightened colors that occur due to her decision not to use a sophisticated coated lens propel the viewer into an inner realm. A student of philosophy and literature, Ess searches for images that provide access to inner experiences. Movement through this world is triggered by sensory perception: symbolic images as well as smell and taste all provide vehicles for memory. Ess taps the narrative depth of simple suggestive symbols. A road as in *Untitled* (No. 47), or a fence, pond, stone wall or emotive gesture can all create an environment in the mind for active contemplation. Because these images are mnemonic rather than didactic, they yield to the viewer intimate outlets for personalized expeditions.

Defining I:

Exploring Identity and Imaging the Self

While photography has provided a means with which to investigate the world and consequently one's place within it, photography also has the capacity to act as a vehicle for the exploration of inner life. When Candide said to Pangloss, "... we must cultivate our gardens"[16] he was referring to the cultivation of the Self. Artistic exploration and self-expression function much in the same way. In this case, photography is the cultivator or hoe with which the "earth" or the self is improved and made hospitable for growth. The women who are featured on the following pages use a diversity of artistic approaches such as formalism and still-life, Surrealism, the self-portrait, masquerade, and other feminist investigations of body and identity to explore the self while simultaneously asking us, as viewers, to question traditional notions of identity, gender and reality.

The Inner I

The still-life, as well as formal investigations of the physical world, can be vehicles for contemplation, self-discovery and symbolic content. Through the arrangement of objects and through the investigation of light, space, texture and volume, personal spaces and miniature worlds are created. These microcosms offer sanctuary from the larger world and are expressions of inner life. The process of identification with these objects can transform them into powerful vessels of meaning.

Utilizing mirrors and geometric forms, Florence Henri followed her interest in Cubism and Constructivism, garnered from her studies at the Bauhaus and with Fernand Léger, and incorporated them with references to the natural world. After World War I, artists had rejected references to the natural world and celebrated instead the logic of a technological world. By the late 1920s, however, the alienating and dehumanizing force of technology and the machine were already subjects for artistic expression. Henri's use of flowers and fruit in still-lifes, such as *Composition Nature Morte* (No. 48), signals the acceptance of nature as an artistic subject and a regard for humanity's place within the natural world, but the fragmentation of the space by the mirrors might also suggest alienation and separation from the natural world.

Imogen Cunningham and Sonya Noskowiak were a part of the West Coast group called *f64* which promoted a purity of vision that was inspired by a primarily German interest in the objective depiction of a subject. Called the New Objectivity, the German movement included both painters and photographers who sought a precise and emotionless delineation of their subjects. In America, a heightened interest in technical prowess differentiated the movement from its European counterpart. California's *f64* group pursued the essence of the object, elevating even the most ordinary of subjects to the distilled perfection of balanced relationships. Cunningham's sharply delineated sculptural plant compositions share the machine-like quality championed by European photographers Albert Renger-Patzsch or Karl Blossfeldt.

Unencumbered by the conventions of the *f64* group, however, Cunningham also experimented with montage and double exposure. Her 1935 photograph *Three Harps* (No. 49) is such an image which, like Florence Henri's *Composition Nature Morte*, creates complex spa-

tial systems from layered or multiple imagery. Cunningham probably was exposed to the works of European "New Vision" photographers who made use of double exposures, solarization, sandwiched negatives and other techniques to distort space and create new ways of seeing the world. Cunningham had a fascination with hands and made many studies in which she tried to capture the persona of the sitter by incorporating aspects of his or her profession. *Three Harps*, which evokes the complex character of music made with that instrument, was made at a time in which Cunningham was photographing visiting artists, instructors and students for Mills College in California.[17]

Sonya Noskowiak, who developed her personal vision in response to the tenets of the *f64* group, combined a respect for visual purity and craftsmanship with an interest in portraying the modern world. Much of her work concentrates on graphic compositions constructed from the industrial landscape. In this regard it is not surprising that Noskowiak chose to represent the architectural qualities of a palm frond. In her *Plant Detail*, 1931 (No. 50) she frames her composition well within the visual boundaries of her subject, isolating the forms and transforming them into the graphic elements of line, tone and formal relationships. Unlike Edward Weston in his studies of natural forms, Noskowiak, who was his assistant from 1929 to 1934, projected the ideals of the Machine Age onto her subjects. In contrast, Weston more often found parallels in natural and human forms.

In *Corn Stalks Growing* (No. 51) Barbara Morgan also concentrates on the graphic and architectural rather than the organic qualities of the plant form. As the German photographer Karl Blossfeldt so appropriately suggests in his *Art Forms in Nature* (*Urformen der Kunst*, 1929), the structures of plants have no doubt inspired many architectural ideas throughout history. A thoroughly modern photograph exploiting the architectonic features of "corn blooms," *Corn Stalks Growing* promotes the formal and graphic qualities of the plant. Morgan's virtuoso lighting also helps to transform the undulations of the leaves into what could be construed as girders or machine parts.

Morgan often expressed the link between man and nature by creating superimposed compositions in which nature and culture intermingle. She was aware of how rapidly the human psyche was changing due to scientific and technological advancements and felt that multiple exposures best expressed the inner workings of the mind and imagination in a society that was rapidly shifting from an industrial to post-industrial phase. Her combination of sharply delineated objects with the experimental fragmentation and layering of images successfully bridges the photographic aesthetics of the European New Vision and the American Precisionists.

Like Imogen Cunningham and Margrethe Mather, Tina Modotti was interested early in her career in revealing truths through the transformation of objects into articles of transcendent beauty and form. However, Modotti soon found her own identity in political activism and began to express her Communist political interests through direct and illustrative images. With the same attention to simplicity and beauty, she photographed objects symbolic of the cause, such as the hands of a worker or a still-life of a hammer, sickle and ear of corn. In

Florence Henri

Swiss (born United States), 1893–1982

Composition Nature Morte, 1931

gelatin silver print

No. 48

Imogen Cunningham
American, 1883–1976
Three Harps, 1935
gelatin silver print
No. 49

85

Sonya Noskowiak
American, 1905–1975
Plant Detail, 1931
gelatin silver print
No. 50

Barbara Morgan
American, 1900–1992
Corn Stalks Growing, 1945
gelatin silver print
No. 51

Mexico, Modotti had taken over the photographic business that she and Edward Weston had established, and she lived on commissions from *Mexican Folkways* magazine as well as Communist publications like *El Machete*.

Modotti made her images of Luis Bunin and his puppets when he was serving as an apprentice to Diego Rivera in Mexico. Bunin's hands, as well as scenes from his plays, were also subjects of Modotti's visual interrogation. The puppets in *Yank and Police Marionette* (No. 52) are from Bunin's interpretation of Eugene O'Neill's play *The Hairy Ape*, 1922, a play with an anti-bourgeois theme.[18] Prison bars are implied both by the shadows and the simple black lines drawn across the background. Although not specifically made to promote the Communist cause, the image nevertheless makes a powerful statement about power struggle and oppression and follows Modotti's interest in connecting life to her art.

Still-life provides a format in which objects can become elevated from the mundane to the singular and take on new meaning. It also provides a way for us to organize and define space. Margaret Watkins, whose compositions of items in her kitchen sink foreshadow those by Jan Groover, found in quotidian objects a beauty that celebrates the "value of simple human life."[19] Her mirror still-life brings similar values to the forefront (No. 53). Watkins adds dynamism to the image by making use of the innovative compositional tactics of the European New Vision. Like Florence Henri, Watkins works with mirrors to fragment space in the manner of Cubism. Made at the time Watkins was producing commercial photography, the composition is daring and modern. Watkins taught at the Clarence White School of Photography and worked as an advertising photographer. She was the teacher of Ralph Steiner and Paul Outerbrige, both champions of the sublime in the mundane. Although Watkins slipped into oblivion after she moved from New York to Glasgow to take care of an ailing family member, her place is being restored to the history of the medium. Her work, which clearly bridges the gap between Pictorialism and Modernism, helped promote modernist aesthetics in the visual language of American advertising.

Formalism has retained a strong presence in contemporary photography despite the predominance of work that addresses issues of broader social purpose. Some of the most successful examples are the compositions of Jan Groover who utilizes everyday objects to explore the potential of photographic seeing. Denying all interpretation of her images, Groover records the tensions and energies that are contrived through the specific location, textures and colors of objects within a picture plane. One of her most successful investigations used simple kitchen utensils (No. 54). The sensuous surfaces of metal objects and the luminous light refractions in the works are a reminder of the Utopian celebrations of harmonious balance in the works of Bauhaus professor László Moholy-Nagy.

Surreal Tableaux As formalist photographers created new spatial arrangements via optical seeing, Surrealist photographers manipulated the medium to create the effect of alternate realities. Although it was a movement primarily dominated by male artists and concerns, Surrealism appealed to women, who also found it to be an ideal vehicle for the exploration of inner life. In photography, Dora Maar, Nusch Eluard and Lee Miller are best known for their involvement in

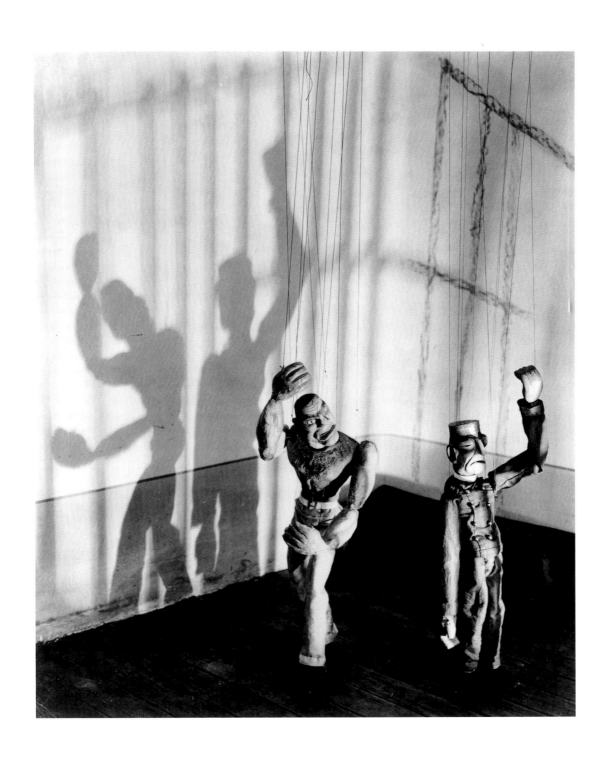

Tina Modotti
Italian, 1896–1942
Yank and Police Marionette, 1929
gelatin silver print
No. 52

Margaret Watkins

Canadian, 1884–1969

Untitled (Still Life with Mirrors and Windows,
NYC), 1927

platinum print

No. 53

Jan Groover
American, born 1943
Untitled, 1979
chromogenic color print
No. 54

Surrealism. Although Dora Maar renounced her association with the Surrealists later in life, her rare and evocative images are powerful reminders of photography's transformative qualities. *Père Ubu*, c. 1936, a photograph of an armadillo floating in formaldehyde, is probably one of the most potent Surrealist photographs of the time. Maar's mysterious photograph of a mannequin in a Paris shop window (No. 55) also synthesizes a number of classic Surrealist strategies. The effect of reflections in windows was a popular subject amongst those photographers interested in Surrealism. Mannequins and dolls also figured prominently in their creations, most often as fetish figures for their male owners. In *Mannequin in Window*, Maar's sensitivity to the layering of reflected images creates a visual field in which we can explore numerous psychic and perceptual dimensions.

Kati Horna plays with the classic Surrealist strategy of body reconfiguration and fragmentation with doll parts popular for their hyper-real effect in her photograph *Doll Parts*, 1933 (No. 56). The deconstruction and distortion of the female figure as a central element of Surrealism was investigated by both male and female artists. One might read the grotesque transformation of the female form in the work of the male Surrealists as a symbol for power displacement anxiety, a fertile topic for the Surrealists and one addressed by Sigmund Freud as "castration anxiety." However, women have also investigated this subject, turning the deconstruction to self-examination, as in Claude Cahun's investigation of diverse gender identities in her montaged self-portrait, *M.R.M. (Sex)* (see No. 66). Horna, who sought the uncanny in everyday life, expressed this interest in these constructed images.

Surrealism continues to offer a means for investigating alternate experiences and states of mind. In lighting, pose, subject matter and composition, Marie Cosindas's photographs evoke Old Master or Pictorialist works. Her specific reference to "art" in the making of her photographs is a continuation of Pictorialist goals to elevate photography to the realm of art and to circumvent the "reality" in its representational capabilities. Yet the effects she uses and her choice of subject matter also allude to an other-worldliness. Dolls, masks (No. 57) and old toys all figure prominently in Cosindas's still-life images. These objects all suggest fantasy, masquerade, illusion and multiple identity.

Masks in particular have been a fertile and frequent symbol in Surrealism, engaging the viewer with either absent or painted eyes; it makes for an unsettling effect—particularly when real eyes gaze back at us from the artificial face. Like the Caligo Memnon butterfly, whose markings resemble the face of an owl and thus ward off predators, masks lock into a similar recognitive layer of the human psyche. Facial features, whether real or artificial, carry primal potency. It is the juxtaposition of the real and unreal with the layering of identities which make masks such powerful symbols.

Like Joseph Cornell's boxes, Olivia Parker's still-life compositions of objects rich in meaning elicit other worlds. The objects themselves, having led past lives, are not transparent, as Vladimir Nabokov once wished in his novel *Transparent Things*.[20] Often utilizing old photographs or making reference to a trace or ephemeral presence as in *At the Edge of the*

Caligo Memnon butterfly
Illustration by Angela Gonzales

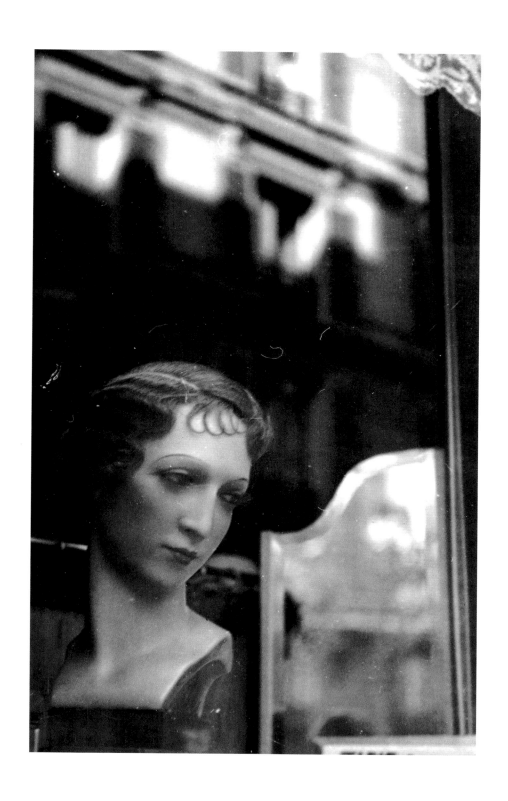

Dora Maar (Dora Markovik)
French, born 1907
Mannequin in Window, 1935
gelatin silver print
No. 55

Kati Horna
Hungarian (born Spain), 1912
(active Mexico from 1939)
Doll Parts, 1933
gelatin silver print
No. 56

Marie Cosindas
American
Masks, 1966
dye transfer print
No. 57

Olivia Parker

American, born 1941

At the Edge of the Garden, 1986

gelatin silver print

No. 58

Garden (No. 58), Parker exploits the objective elements of the photographic process while at the same time creating an alternate reality. Parker's compositions most often represent an interior world, but *At the Edge of the Garden* is about a world outside. In this image Parker illustrates her theme of *anima motrix* (the moving spirit found in objects) by personifying the spirits as shadow-figures moving in a garden. Parker's photographs often link nature and culture, converging the material world of culture with the ephemeral world of nature.

The Public I

Advertising flourished in the 1920s as design innovations provided avenues for the integration of photography, thus expanding the visual language of commercial enterprise. As women gained freedom and independence in society, they recognized an expressive and economic potential in photography. Many women-run studios sprang up in Europe, England and the United States, translating the vision of Modernism into images for commercial consumption. In Germany the collaborative studio of ringl + pit (Grete Stern and Ellen Auerbach) and Atelier Yva run by Else Simon (called Yva) were among the enterprises specializing in product and fashion photography (Nos. 59, 60). However, the expressive and economic outlet for many was short-lived as Jewish businesses were forced to close down and Jewish photographers were censored in the media. Many continued to photograph and publish under pseudonyms, but it became increasingly dangerous for them to remain in Germany or in other Nazi-occupied countries. If they did not flee, as many did, they faced imprisonment and death. Yva (Else Simon) was one of the casualties of the Nazi terror, dying in a concentration camp in 1942. Other photographers, including Ellen Auerbach, Grete Stern, Lucia Moholy and Lotte Jacobi emigrated in the mid-1930s.

An aspect of commercial photography, dance photography in the 1920s and 30s combined the modern scientific interest in analyzing time and movement with the more humanistic investigation of personal expression. Charlotte Rudolph, Jane Reece, Nelly (Elli Seraïdari) and Ursula Richter all photographed women's expressionist dance as an outlet for their own expressive interests as well as for commercial purposes. Time, motion and emotive physical form were merged in this harmonic relationship between dancer and photographer. These images illustrate a freedom of expression and confidence in the power of the female body. Expressionist dance in the 1920s was a radical artistic form which provided women with an outlet for personal expression and self-discovery.

Charlotte Rudolph (No. 62), who analyzed movement in both visual and structural terms, contributed to the discourse of dance through her article on dance photography. There she explored the intricacies in the organization of motion by breaking dance into "principal movements" (moments of tension, relaxation or suspension) and transitional moments (moments of changing from one movement to another).[21] Ursula Richter, like Rudolph, was a professional photographer whose main focus was portraiture, theater and dance photography. In *Totentanz* (*Dance of Death*) (No. 61), as well as in Jane Reece's *Triangle Composition* (No. 63), a dichotomy exists between the static nature of the poses and their reality as evocations of movement.

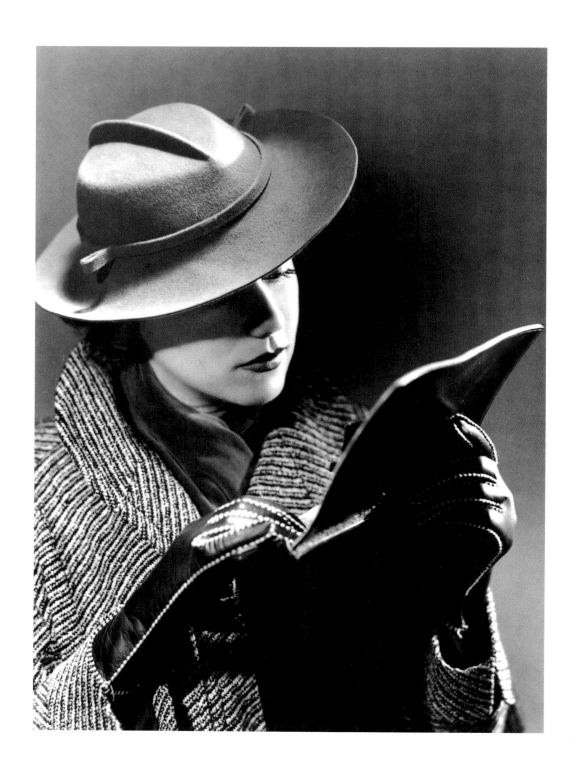

Yva (Else Simon)
German, 1900–1942
Untitled, 1935
gelatin silver print
No. 59

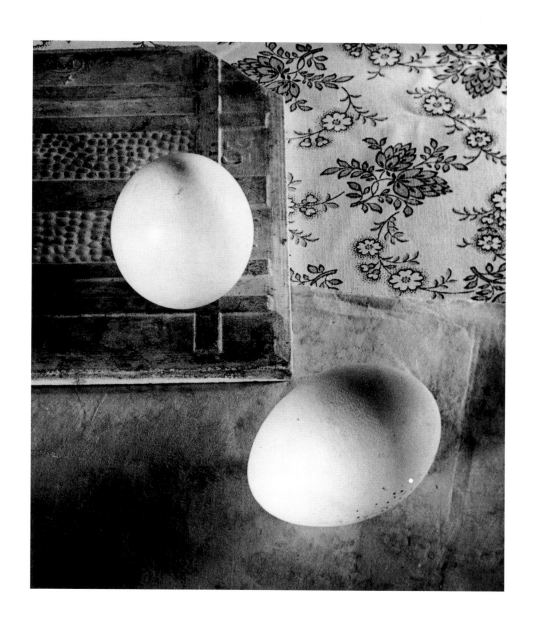

ringl + pit
German
Das Ei des Columbus (Columbus's Egg), 1930
gelatin silver print
No. 60

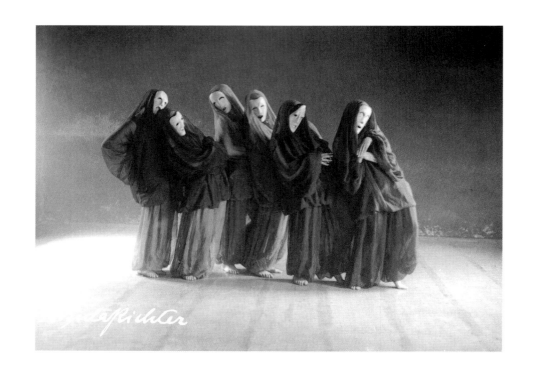

Ursula Richter
German, 1886–1946
Totentanz, 1926
gelatin silver print
No. 61

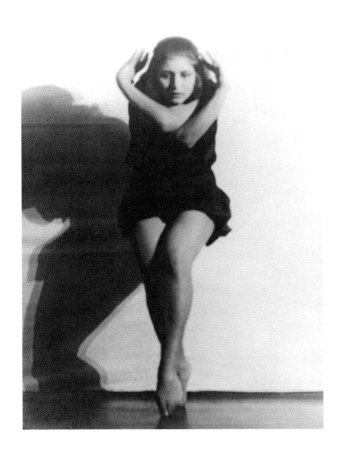

Charlotte Rudolph
German, 1896–1983
La Danseuse Margarete Wallmann, 1920s
gelatin silver print
No. 62

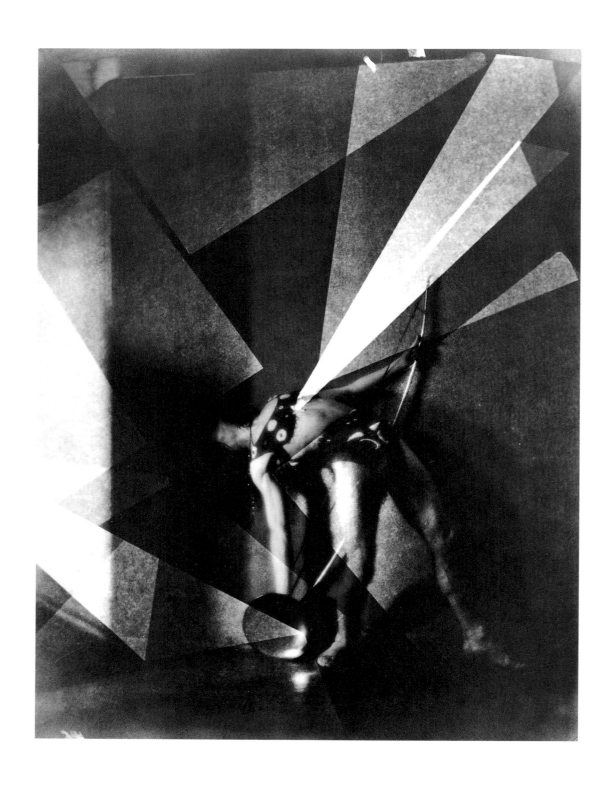

Jane Reece

American, 1869–1961

Triangle Composition, 1922

gelatin silver print

No. 63

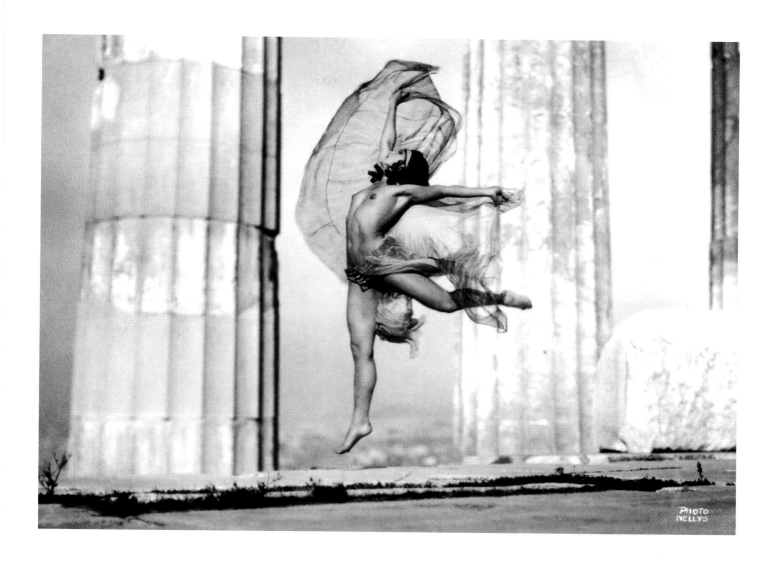

Nelly (Elli Seraïdari)
Greek (born Turkey), 1899
The Russian Dancer Nikolska at the Parthenon,
1929
gelatin silver print
No. 64

Alma Lavenson

American, 1897–1989

Self-Portrait, 1932

gelatin silver print

No. 65

Jane Reece brought to her dance images the early expression of Cubist and Modernist ideas. She created an illusion of fractured space through her application of tissue in geometric forms across the image (in the manner of a photogram) in *Triangle Composition*. With this effect, she provides a heightened sense of drama, creating a play between the lines of the body and the added design elements.

Nelly (Elli Seraïdari) photographs her subject against the Acropolis (No. 64), laying claim to ground that has symbolized the ideal of (masculine) Western civilization. Nelly celebrates the power of a woman's body as an active catalyst for personal expression and, to some extent, subverts its potential for objectification. The female nude has a long history in artistic practice as the passive object of the male gaze; photographers, both male and female, have systematically carried on this tradition. Helen Kornblum has been opposed to collecting nudes because they objectify and fetishize women's bodies, promoting passivity rather than an active engagement in the world.

Image and Identity

In artistic practice and in leisure activity, women's bodies have served as objects of the male gaze for centuries. This triangular dynamic of the delineator (photographer/artist), the observed (subject), and the observer (consumer/viewer) leaves no opportunity for a subject's definition of herself. Questioning and disrupting this convention have been artist-photographers like Claude Cahun, Gertrud Arndt, Cindy Sherman, Ana Mendieta, Hannah Wilke, Carrie Mae Weems, Lorna Simpson, Hulleah Tsinhnahjinnie, Annette Messager and others working outside the mainstream, who use photography to analyze this experience in social and political terms. Some of these women have reconfigured the relationship of the viewer to the subject by repositioning themselves as protagonist. Their investigations often explore the role that the female body has played in the establishment of identity. Frequently utilizing self-portraiture, these artists are reclaiming the power to create their own representations of themselves and of the female experience.

Alma Lavenson makes a strong gesture of self-definition when she records herself in the guise of a camera. In her *Self-Portrait* (No. 65) only the cyclopic lens of a large camera regards us from the frame, though she humanizes the photograph by including her hands. The camera frames her identity, while her gaze (*as camera*) focuses directly back on the viewer who becomes the object of the gaze. By this means, she asserts power not only in establishing her own identity, but also in the manipulation of the viewer's position and relationship to the image.

Artist, writer, critic, poet and political revolutionary, Claude Cahun was a complex woman whose many-faceted personas were both confounding and revealing. Constructing and reconstructing her gender and identity before the camera, she effected transformations that are as much about "image" as they are about the mutable nature of gender. Cahun created characters that rely on the photograph to make them "real." The images are documents of performances that acknowledge the camera as an active participant in the event. Cahun's work has been described as a predecessor to the masquerades of Cindy Sherman. Unlike

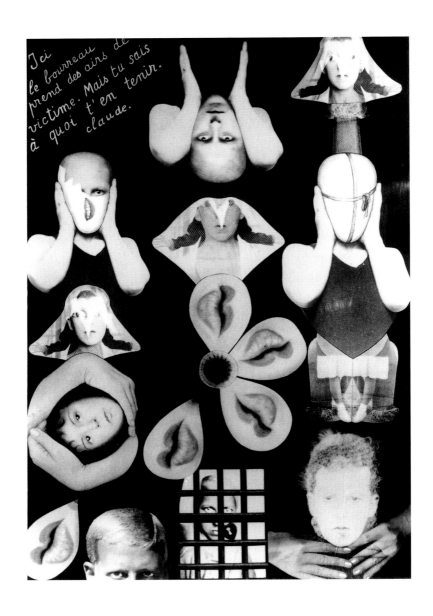

Claude Cahun (Lucy Schwob)
French, 1894–1954
M.R.M. (Sex), 1936
gelatin silver print
No. 66

Sherman, however, Cahun does not merely see herself in one guise at a time: through collage and montage she often offers a number of alternatives within the same framework.

In 1930 Cahun published *Aveux Avenus (Unavowed Confessions)*, a book in which she explored her varied personalities in collages, posing questions that expose the complexity and dichotomies of gender identification. In *M.R.M. (Sex)* (No. 66), a photomontage from that book, she presents images of herself as androgynous, coquettish, and completely devoid of identity. Cahun's text written in the corner states: *"Here the executioner takes on the airs of a victim. But you know what to believe. Claude."* She includes photographs of herself being strangled; with her lips enclosed in the petals of a flower; in prison with a heart-shaped keyhole on the bars. (The latter is significant and ironic in that she and her female lover were later arrested by the Nazis for "subversive" activities.) In her multi-layered images, Cahun challenged gender roles and their representation by emphasizing their artificiality through the constructive/deconstructive technique of the collage.

Gertrud Arndt, a student at the Bauhaus from 1923 to 1927, explored the self and its potential through 43 self-portraits made in 1930 (No. 68). In playful yet significant images, she presented herself as Woman of the World, Femme Fatale, Oriental Exotic, Bourgeois Lady, Widow, Child, and Young Woman. In them, her face expressed studiousness, shyness, coquetry, mourning, concentration, lust, surprise, gaiety and indifference. In these sometimes satiric studies, Arndt presents an interpretation of the multiplicity of the female persona. Sabina Leßmann speaks of the self-portrait in reference to the "New Woman" of Weimar Germany in her essay *The Mask of Femininity Takes on Curious Forms (Die Maske der Weiblichkeit nimmt kuriose formen an. . . .* "[22] She points out that the activity of self-representation best expresses the freedom and independence that the "New Woman" was able to experience. Arndt's experimentation with different personas contributed to her search for self.

Hannah Wilke in her *S.O.S.—Starification Objects Series*, 1974, (No. 67) undermines traditional poses derived from the clichés of boudoir, soft-porn or fashion photography by placing numerous vulval forms made from chewing gum on her face and body. To underscore her critique of exploitational representation, her play on words in the title also alludes to "S.O.S.," the international distress signal. Acknowledging the object-ness of the body, Wilke sticks the chewing gum forms to her face, subverting the erotic nature of the photographs. Referring at once to scarification as practiced in Africa and its relationship to Western rituals of beauty, the gum forms also refer to the atrocities committed by Nazis on the bodies of Jewish women.[23] The curlers in this portrait from the series also make reference to the "voluntary tortures" that Western women have undergone in the name of beauty.

Wilke's striking beauty was problematic both in her early life and in her life as an artist. Part of her critique of feminine stereotypes comes through her exploitation of her beauty which she used to undermine those traditions. For Wilke, her public displays of her body as object functioned to reassert her power over her body and self. The narcissism in her photographic exploration was not a passive relationship of love for self, but an active self-assertion: she reaffirms the self by creating a "body-consciousness."[24] Wilke's representations were unique

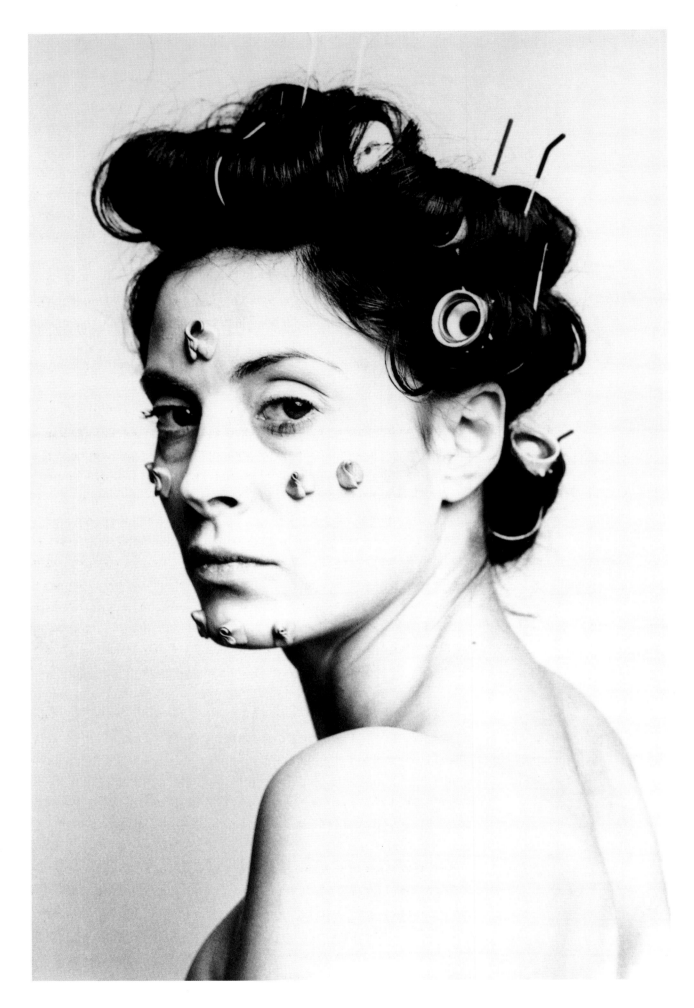

in that she used her beauty to call attention to the way beauty is paramount in our society. When she was diagnosed with lymphoma, she documented the decline of her body and its beauty, often representing herself in the "fashion" poses which she had utilized in her earlier work. Wilke, who had also documented her mother's breast cancer, confronted taboos of body-image that ideals of beauty conceal.

Like Wilke, Cindy Sherman has made the act of looking an integral part of her work. Although it first appears that she is the object of the gaze, remaining ever *object*, Sherman's act of pinpointing the stereotypes and replaying them in great detail turns the tables on the viewer/viewed relationship. Her many self-portraits in which she appropriates the representational traditions of film, fashion photography, pornography and art history function as an exploration of the stereotypes of feminine representation in Western cultural history. Her depiction of herself as multiple personas refers not only to a historical and mostly male tradition in art (consider Rembrandt's many self-portraits and his casting of himself in various biblical roles), but it is also an assertion of power. By confronting the gaze through masquerade, Sherman represents herself rather than having identity imposed on her by others.

The constructed nature of Sherman's images also draws attention to the artifice in the representation of femininity in both popular culture and high art. In her *History Portraits* series, (No. 69) Sherman undermines the exalted status of "Old Master" paintings by exaggerating distortions and flaws of the body. Stereotypes and image ideals have occupied a place of primacy in the establishment of self and image throughout the history of art. Sherman exposes these constructions by making us aware of their artificiality. When placed in context with her earlier work, Sherman's juxtaposition of Renaissance ideals with contemporary images of femininity shows a continued interest in manufactured identity.[25] Sherman's portraits, in all their personal and political existence, are potent containers of meaning. Described by various critics as either playing to or subverting the male gaze, the images retain strength through their ability to elicit multiple readings. However, in the process of exposing the multiplicity of the self, Sherman, like Gertrud Arndt before her, reclaims a woman's right for self-definition.

In *Self-Portraits* (No. 71), Lorie Novak investigates identity and personal history through the layering of projected or superimposed images that derive from both personal archives and popular culture. While Cindy Sherman's characters provide a substantive canvas on which the viewer can project personal experiences both real and constructed, Novak creates evocations of identity by tapping the presence of memory through the layering of projected family snapshots onto the walls of rooms, furniture, and outdoor environments. The iconic and familiar scenarios—family portraits and images of mother and child—intermingle to create layered images that represent the complexity of the constructed self. Images of the family are revealed as both representations of mythological ideals (The Happy Family, The Madonna) or surrogate memories, depending on the viewer's experiences. Photographs both define and remind us of our past. They can also promote realities that never existed. Memory is also shaped by both real and imagined experiences and Novak's images seem to illustrate this process. As in *Self-Portraits*, 1987, the images of family become a veneer which

Hannah Wilke
American, 1940–1993
S.O.S.—Starification Object Series, 1974
gelatin silver print
No. 67

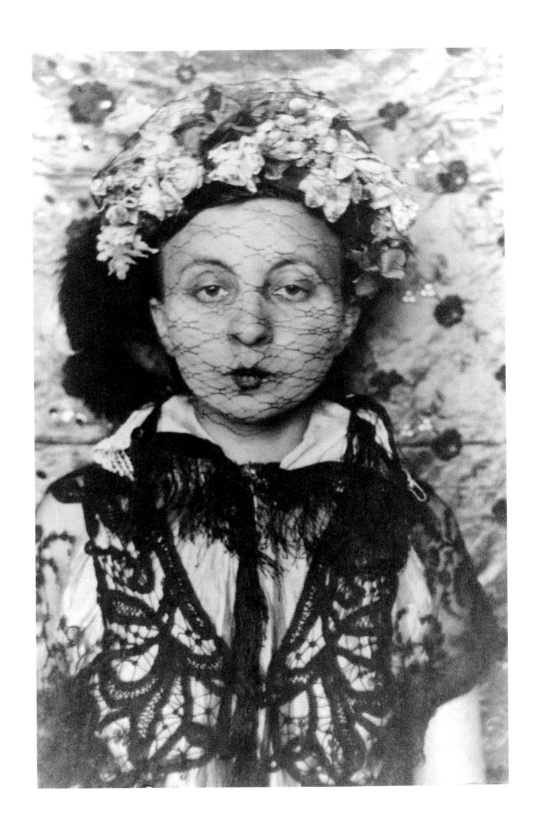

Gertrud Arndt

German, born 1903

Self-Portrait with Veil, 1930

gelatin silver print

No. 68

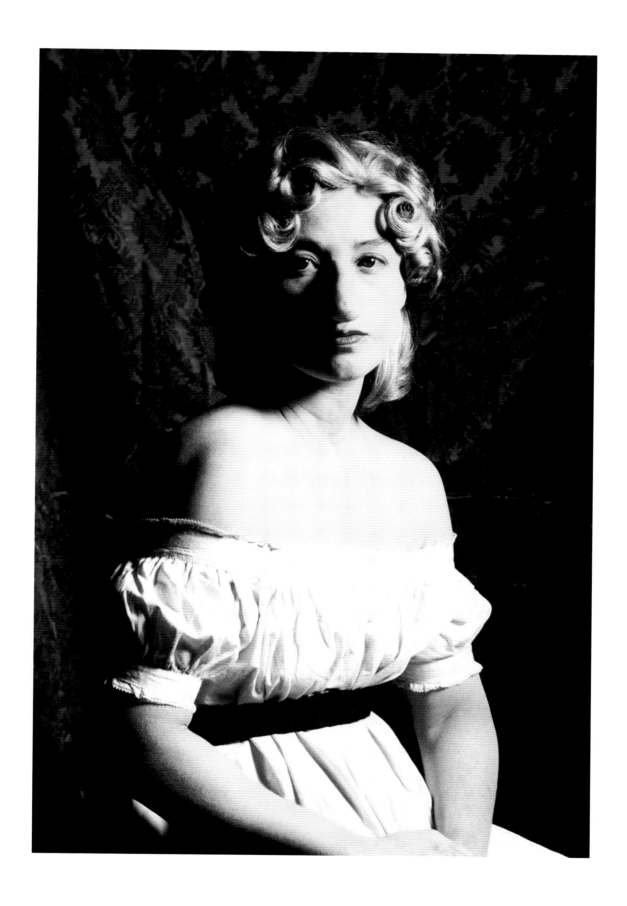

Cindy Sherman

American, born 1954

Untitled, from the *History Portrait* series, 1989

chromogenic color print

No. 69

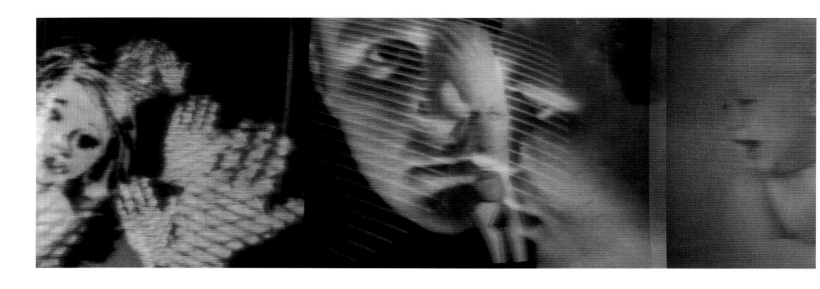

Sandra Haber
American, born 1956
Untitled, 1987
chromogenic color print
No. 70

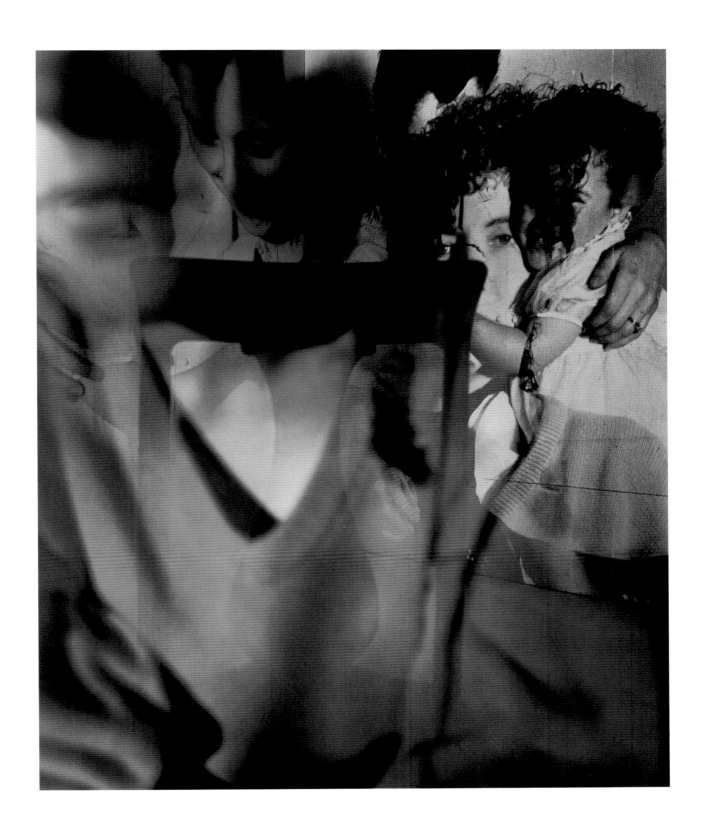

Lorie Novak
American, born 1954
Self-Portraits, 1987
chromogenic color print
No. 71

floats over an underlying structure of reality. The chair in *Self-Portraits* is at once substantial and a ghostly reminder of human presence. Like Barbara Ess and Sandra Haber (No. 70), Novak employs the symbolic potential of floating visual symbols to touch on inner experiences. Novak's images also reveal the structure of human relations and their effect on the formation of self.

Carrie Mae Weems addresses the issue of the constructed nature of femininity in *Untitled* (No. 72) from the *Kitchen Table* series. In this tableau, Weems exposes the construct of feminine identity both by making reference to the perpetuation of feminine ideals through family relations, and by implication through her use of photography as the imaging device. Identity is shaped in part by images that we encounter on an everyday basis. In magazines, on television and in films, women are regularly confronted by feminine ideals that are either unrealistic or fictitious. By constructing these tableaux, Weems, like Sandy Skoglund, Cindy Sherman and Eileen Cowin, uses photography to emphasize its capacity as a representational rather than factual medium.

In the larger scope of the *Kitchen Table* series, Weems weaves images of familial dramas, both subtle and monumental in their emotional import, with quotations drawn from folk sayings and songs. She provides a narrative in which the voice of the African-American woman plays the protagonist's role. Weems made the *Kitchen Table* series partially in response to Laura Mulvey's critical analysis of the problems of female representation.[26] Weems notes that in her critique, Mulvey does not address the issue of the representation of women of color.

Lorna Simpson also articulates the experiences of African-American women, often by combining simple sculptural and anonymous figures and text fragments dense with meaning. Like Weems, Simpson makes text an integral part of a photograph. Her often code-like texts analyze and deconstruct language, underscoring its ability to produce multiple meanings, and exposing mechanisms of racism and stereotyping prevalent in today's society.

In her series of 21 photogravures titled *Details* (No. 73), she uses these same principles to focus on body language, gesture and what they can imply. Each image is a fragment of an appropriated studio portrait cropped to channel our attention to the hands of the subjects. Simpson's subtle combinations of gestures and props, coupled with her usual weighted text like "carried a gun," "in love and tried to stay out of trouble," "stopped speaking to each other," or "soulful" give the series rich potential for narrative exchange in which the viewer plays a primary role. Simpson created a series of 21 images in which the individual pieces have no particular order and can be hung together or separately. These are not portraits of individuals but "portraits" of human relations as well as illustrations of our prescribed expectations of learned race and gender expectations.

Hulleah Tsinhnahjinnie uses collage to challenge white American and Eurocentric mass-media stereotypes in her series, *Native Programming*. Speaking to the lack of Native-American characters and programming in the media, she frames her images in the window of a television set, recreating media representations "Native American style." To this end,

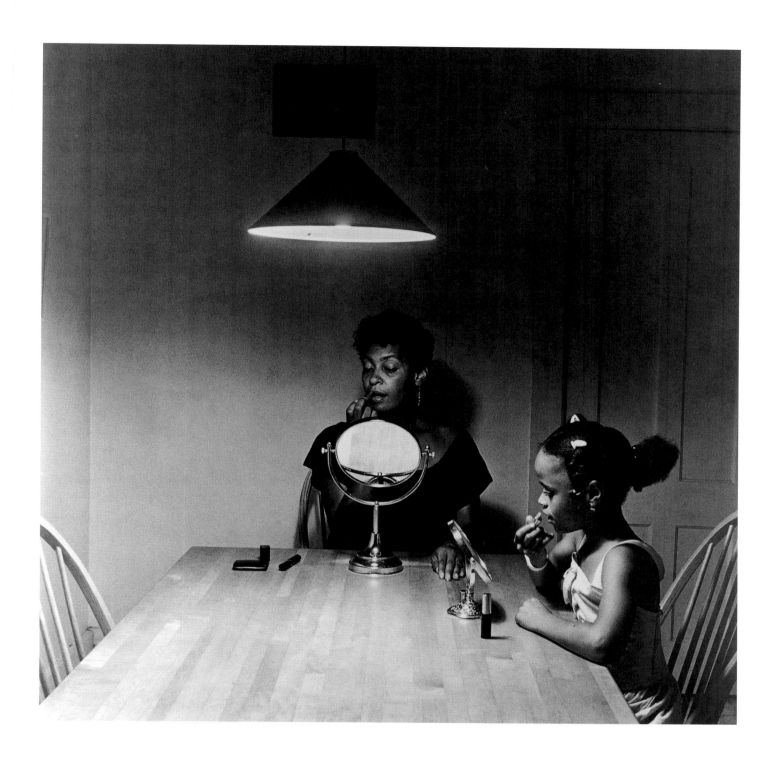

Carrie Mae Weems
American, born 1953
Untitled, from the *Kitchen Table* series, 1990
gelatin silver print
No. 72

carried a gun

in love and tried to stay out of trouble

stopped speaking to each other

soulful

Lorna Simpson
American, born 1960
Details (a selection of four), 1996
21 photogravures
No. 73

Hulleah Tsinhnahjinnie
American, born 1954
Vanna Brown, Azteca Style, 1990
gelatin silver print photocollage
No. 74

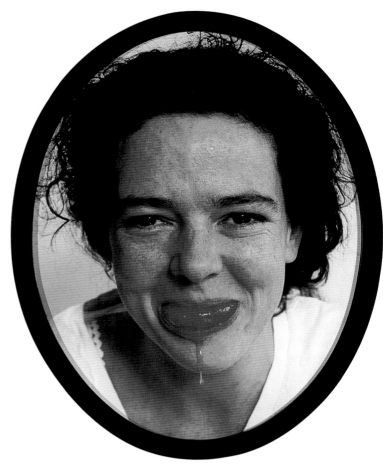

Jeanne Dunning
American, born 1960
Leaking 2, 1994
pair of silver dye bleach prints
No. 75

Tsinhnahjinnie created a new set of characters that represented Native American culture. In her scenario *Vanna Brown, Azteca Style*, (No. 74) she casts her friend, the lawyer Francisca Marie Herrera as the host of a television show in which she speaks with depth about complex issues of social injustice in contrast to her prime time counterpart, Vanna White, on Wheel of Fortune, who represents the typical blonde ideal woman who occasionally produces small talk, but remains a mute puppet for much of the show. Tsinhnajinnie's character takes charge of her identity, creating an awareness of stereotypes and their alternatives.

Like Sherman and Weems, Sandy Skoglund and Laurie Simmons also refer to the constructed nature of feminine identity through fabricated tableaux. Both Skoglund's *At the Shore* (No. 76) and Simmons's *Three Red Petit-Fours* (No. 77) allude to how women's bodies are both likened to and affected by food. The images also reveal how unrealistic expectations generated by popular culture can affect body image. Barbie, whose measurements in scale on a real woman would make her monstrous, is presented as an ideal body type. In *At the Shore*, Barbie happily traverses a sea of french fries (fast food has helped undermine both the quality of mealtime and complicated the quest for "the perfect body"). Simmons's image reminds one of the folk quotation that delineates a girl's character as all "sugar and spice and everything nice." Reduced to their fetishistic parts: legs with a candy head, the women are literally consumable objects. By utilizing toy representations of women, both Simmons and Skoglund make critical statements about how women have been represented as objects or "playthings." Laurie Simmons and Sandy Skoglund also use toys to raise questions about how we perceive reality. By juxtaposing the real and the artificial, both artists question reality in general and, more specifically, how it relates to camera-imaging. Critical events in photographic history, like Arthur Rothstein's movement of the skull in his FSA photographs, had already begun to shatter the public's trust in the veracity of the medium by the mid-1930s. Artists like Kruger, Simmons, Sherman and Sherrie Levine have taken on this issue, exposing mechanisms used by the media to form and perpetuate stereotypes. By using artifice, these artists further underscore the potential insubstantiality of this seemingly truthful medium.

Confounding expectations of normality, gender and sexuality, Jeanne Dunning questions the nature of photographic reality and exploits its transformative capabilities in her closeup photographs of facial features, fruits and vegetables, and portraits. The body and its representation are the foundation of Dunning's investigations, and in her series *Leakings* she brings together the portraiture that she utilized in her series on feminine bodily imperfections (facial hair, moles, spider veins) with the skinned fruit that she previously used to symbolize the vulnerability of our bodies. Like Man Ray, who saw in objects the potential for another life, Dunning also finds alternative referents in objects. In an earlier series, Dunning made closeup photographs of skinned plums from which she had pulled the stems. The dark holes that were left after the stems had been pulled offered the viewer an unnerving experience of questioning the object's identity. Its fleshy surface yielded a number of interpretations that have to do with body parts.

Framed in ovals that make us think of cameos or traditional 19th-century portraits, the subject in *Leaking 2* (No. 75) faces the viewer with a direct gaze. A skinned tomato oozes

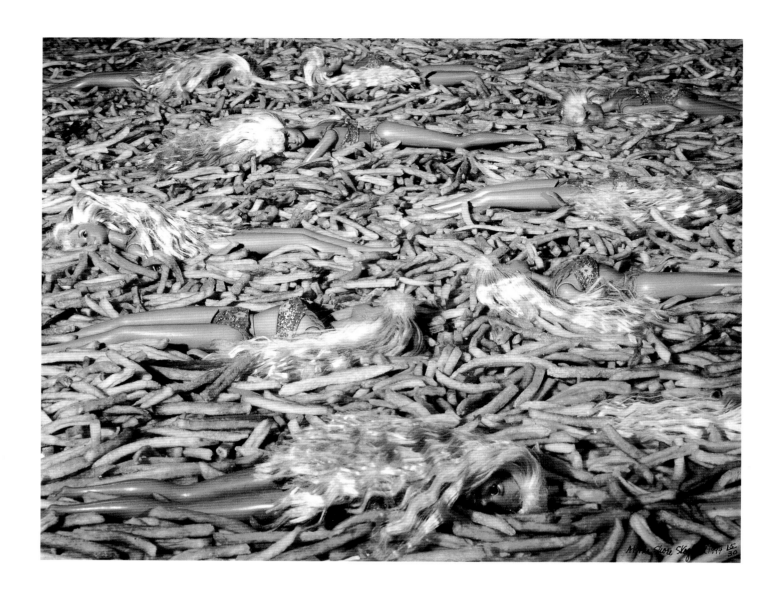

Sandy Skoglund

American, born 1946

At the Shore, 1994

silver dye bleach print

No. 76

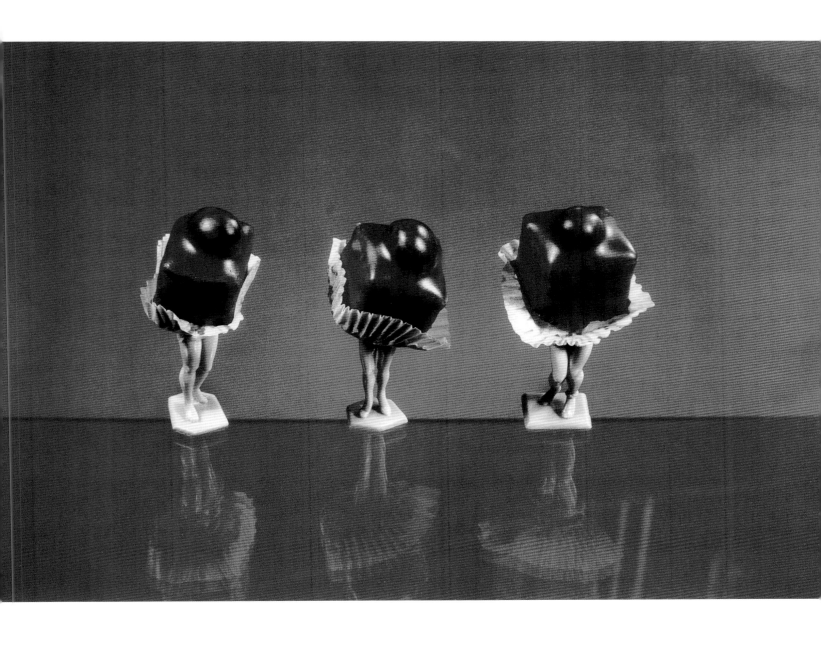

Laurie Simmons
American, born 1949
Three Red Petit-Fours, 1990
silver dye bleach print
No. 77

from the woman's mouth. With this image, Dunning wishes to evoke a sense of freedom, playfulness and delight — the pleasure of "letting go." This image is a metaphor for the release of inhibitions both bodily and emotionally. In a similar oval frame next to the image of the woman is a "portrait" of the skinned tomato that fills the frame. We are confronted by wet, veined flesh. A fragment of the body framed for our delectation? By associating the flesh of a tomato with the flesh of a human body, Dunning subverts the delectation that so commonly accompanies a traditional study of the female form. Instead our gaze is repulsed by a fleshy object which suggests a flayed body. Dunning's two images seen together are an expression of inside and outside; the contained and the exposed; the controlled and the uninhibited.

Cuban artist Marta María Pérez Bravo's photographs deal with body issues in terms of the paradoxical experience of motherhood. Responding to a difficult pregnancy in which she gave birth to twin girls, Marta Pérez makes self-portraits in which she uses her own body as a site of ritual and expression. Steeped in both Afro-Cuban and Christian religious references, she prepares her body like an altar, drawing lines and placing objects such as shells and cups on its surface. In images that refer to the birth of her twins, she questions the myth of exalted motherhood. Often referencing the violent nature of birth, she does not celebrate the process. In several of the images of motherhood Pérez uses small plastic babies to evoke the socially unsanctioned dichotomies of the emotional experience. In *No vi con mis propios ojos* (*I did not see with my own eyes*) (No. 78) the plastic babies form a blind across Pérez's eyes; in *Fear of Death* they are surrogates for the pennyweights placed on the lids of a corpse. However in *Macuto* (the name for a receptacle of power in the African *palo monte* cult), the dolls form the center of the receptacle which is symbolized by Pérez's cupped hands. Pérez's images expose women's ambivalent feelings towards motherhood and question the myth of the innate mothering instinct. By laying bare these issues, she makes it possible for women to explore and come to terms with the feelings of guilt which are formed in response to socially constructed and perpetuated myths about mothering and motherhood.

In opposition to the belief that identity is formed through the vast array of social, cultural and economic forces are the essentialists who believe that feminine identity is derived from biological sources. Celebrating the "essential" or biological nature of feminine identity in this collection are Anne Brigman and, more recently, Ana Mendieta and Ruth Thorne-Thomsen, who have considered the body relative to the environment in poetic or spiritual terms.

Anne Brigman's photographs of women in the landscape seem radical when placed in the context of the prevailing artistic practices of the time. Although Brigman utilized the romanticizing Pictorialist conventions of soft focus, the women she placed in the landscape appear to be powerful mythical figures, asserting their place in the world outside (No. 79). Inside and outside have been defined in terms of the domestic (world of women) and public (world of men). These ideas are perpetuated through the media's depiction of men and women in their environments, particularly in advertising. Men are most often represented outside, engaging in activities which are external, while women have been consistently placed

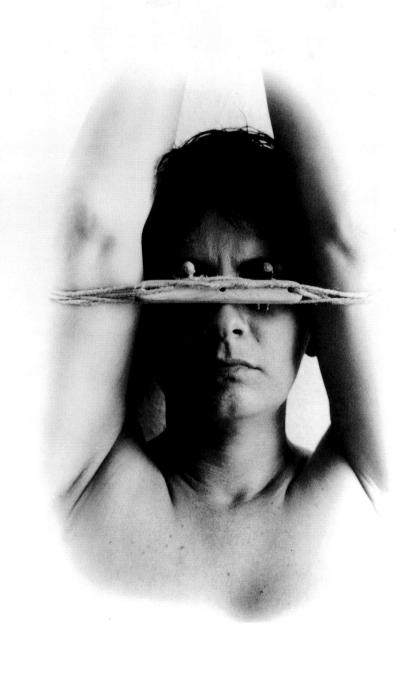

Marta María Pérez Bravo
Cuban, born 1959
No vi con mis propios ojos
(I did not see with my own eyes), 1991
gelatin silver print
No. 78

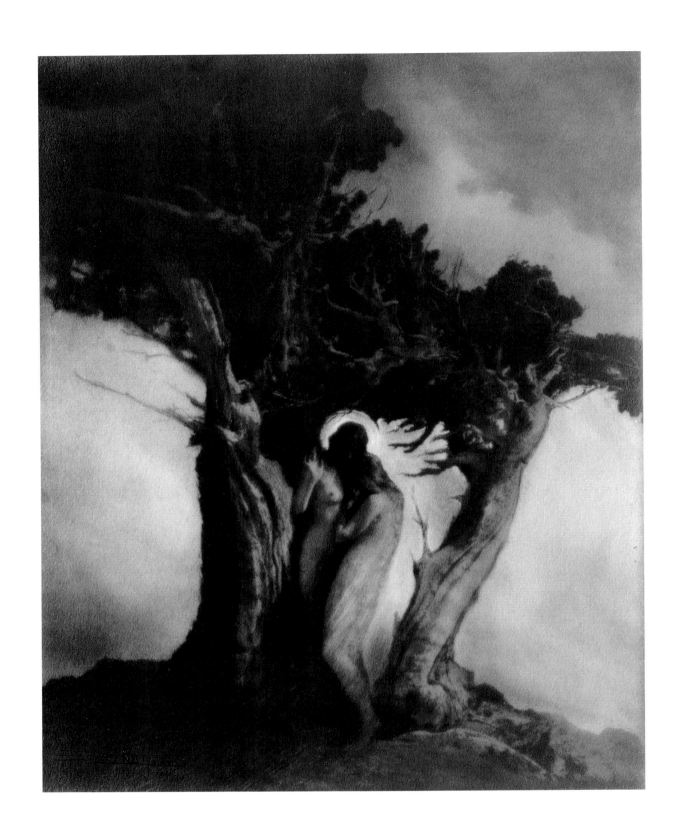

Anne W. Brigman

American, 1869–1950

The Heart of the Storm, 1910

gelatin silver print

No. 79

Ana Mendieta
American (born Cuba), 1948–1985
Birth, from the *Isla* series, 1981
gelatin silver print
No. 80

in the domestic environment. It is only recently that women have been represented in more active outdoor pursuits. Brigman's images are also radical in that during this time it was acceptable only for men to depict nude women.

Brigman's women are of the landscape, not in the landscape. Unlike the women portrayed in photographs by Edward Weston or Wynn Bullock, whose female figures are merely objects of the gaze within the landscape and thus in formal terms compared to aspects of the land, Brigman's figures are shown as emanating from the land or as part of it. Brigman found in the natural environment a link to her spirit as a free individual and saw in nature anthropomorphic forms from which she created a kind of pagan pantheism. Using herself and a few friends as models, Brigman created photographs that are a celebration of women's development and self-assertion. They reveal a connection to the body without mediation.

Ana Mendieta, in the mid to late 1970s, also explored the body's connection to earth with sculptures that she etched into the landscape in a ritualistic process (No. 80). Figures made of sand, stone, rocks, and plants were site-specific. These sculptures were intimate "imprints" of a woman's body and only temporarily scarred the landscape. Wind, water, erosion and plant growth would soon return the places to their original form. Due to the transient qualities of her sculptures (an integral part of her message), photography became the medium which documented her work, creating a relationship between the intangible and the tangible (the sculpture and the photograph).

Born in Cuba, Mendieta wanted to reassert the ties to nature and the land which she felt had been severed both in her cultural and spiritual life. The revolution in Cuba had prompted her parents to send Mendieta to the United States, where she lived not with family members, but in orphanages and foster homes. Distanced from her family and homeland, she compared this separation more generally to an alienation from nature. She saw nature as a maternal source, and she equated her move from Cuba to being torn from the womb. As a woman, she saw her link to nature as essential to self-discovery.

At once body art, earth art, performance and photography, the results of Mendieta's investigations used mythological themes of the goddess as well as elemental metaphors to collapse the distance between the body and nature. Unlike Cindy Sherman or Laurie Simmons, who look to popular culture, Mendieta searched for what she considered to be the root, for the answer to woman's alienation from her body. For Mendieta that meant reconnecting to nature in order to assert the body's role as a sensual source and giver of life.

Ruth Thorne-Thomsen, in her series *Views from the Shoreline*, which includes *Flora Bella* (No. 81), explores the connections of mind, body, nature, landscape and history using the fertile ground of the Italian landscape. The formal development of *Views from the Shoreline* was inspired in part by iconic portraits by Piero della Francesca whose simple and bold profiles are set against the Italian landscape as a theater for her constructed scenes. Thorne-Thomsen's profiles, not unlike 19th-century silhouettes, are the heads of friends, both male

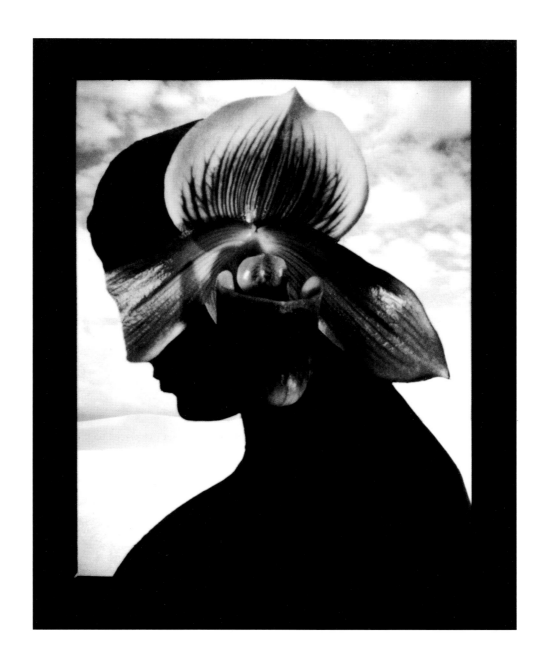

Ruth Thorne-Thomsen
American, born 1943
Flora Bella, 1987
gelatin silver print
No. 81

127

and female, and heads of classical Greek and Egyptian sculptures. The images from which the heads are cast are derived from both natural and cultural sources: flowers, shells, clouds and geological formations as well as modern and ancient architecture float within the outlines. The title of the series, *Views from the Shoreline*, refers to what Thorne-Thomsen terms "the edge of the ocean of the unconscious."[27]

Thorne-Thomsen integrates the feminine and the constructed masculine in her photographs. Although her images are derived from primarily Western mythological sources, the ideas represent universal issues. Unlike Mendieta, Thorne-Thomsen's definition of self is less gender specific, however naturally gendered a viewpoint it may be. In defining herself by locating her persona within the context of historical artifacts, Thorne-Thomsen defines a collective experience as well.

* * *

Helen Kornblum's collection speaks of the complex relationships among ourselves, our environment and our inner lives. The women whose work is featured in this unique collection have expressed their individual identities through the images that they have created, often overcoming great obstacles in the process. In this quest, they have made specific and definitive choices, as has the collector of these photographs: a woman who has made it a mission to collect the art of women photographers. This extraordinary collection is nurtured by a drive to pinpoint those voices, to hold them out for discussion and to bring them into the public arena. The photographs in this collection testify to the vitality, originality and legitimacy of the experiences of these women artists. Marion Post Wolcott said it well:

Women are tough, supportive, sensitive, intelligent, and creative. They are survivors. Women have come a long way, but not far enough. Ahead still are formidable hurdles. Speak with your images from your heart and soul. Give of yourselves. Trust your gut reactions. Suck out the juices—the essence of your life experiences. Get on with it. It may not be too late.[28]
—Marion Post Wolcott

Notes

1. Barbara Head Millstein, *Consuelo Kanaga: An American Photographer*, Brooklyn: Brooklyn Museum in association with the University of Washington Press, 1992, p. 22.

2. *Cosmopolitan,* September, 1952.

3. Susan Sontag, *On Photography*, New York: Farrar, Strauss and Giroux, 1977, p. 43.

4. Sandra Phillips, *Helen Levitt*, San Francisco: San Francisco Museum of Modern Art, 1991, p. 27.

5. Martha A. Sandweiss, *Laura Gilpin, An Enduring Grace*, Forth Worth: Amon Carter Museum, 1986, pp. 51–53, 79.

6. Salomon Grimberg, *Lola Alvarez-Bravo: the Frida Kahlo Photographs*, Dallas: Society of Friends of Mexican Culture; New York: Distributed by D.A.P., 1991.

7. Marianne Fulton, *Mary Ellen Mark: 25 Years*, Boston: Little, Brown, 1991, p. 25.

8. Doris Ulmann, The *Darkness and the Light: Photographs by Doris Ulmann*, Essay by Robert Coles, p. 7.

9. Rolf Sachsse, *Lucia Moholy: Bauhaus Fotografin*, Berlin: Bauhaus-Archiv, 1995, p. 19.

10. Lange made this comment while trying to persuade John Szarkowski to keep a photograph that he considered sentimental out of her exhibition. Quoted in A.D. Coleman from "Letter from New York No. 73," *Photo Metro*, vol. 14, issue 139.

11. Conversation with Buffie Johnson, December 13, 1996.

12. Milan Kundera, *Immortality*, translated from the Czech by Peter Kussi, New York: Grove & Weidenfeld, a division of Grove Press, 1990, p. 305. " ... For every event, no matter how trivial, conceals within itself the possibility of sooner or later becoming the cause of other events and thus changing into a story or adventure. Episodes are like landmines. The majority never explode, but the most unremarkable of them may someday turn into a story that will prove fateful to you."

13. Dorothy Norman, *Intimate Visions: The Photographs of Dorothy Norman*, edited with an essay by Miles Barth, New York: International Center of Photography, 1993, p. 26.

14. Lucy Lippard, "Philosophical Fallout," *Z Magazine*, vol. 7, No. 4 (April 1994): 52–54, p. 53.

15. Ibid, p. 54.

16. Voltaire, edited by Norman L. Torrey, *Candide*, Arlington Heights, Illinois: AHM Publishing Corporation, 1946, p. 115.

17. Richard Lorenz, *Imogen Cunningham: Ideas Without End: A Life in Photographs*, San Francisco: Chronicle Books, 1993, p. 41.

18. Sarah M. Lowe, *Tina Modotti: Photographs*, New York: Harry N. Abrams in association with the Philadelphia Museum of Art, 1995, p. 43.

19. Halla Beloff, "A Lost Femininity" in Martha McCulloch, ed. *Margaret Watkins 1884–1969: Photographs*, Essays by Halla Beloff, Joseph Mulholland and Lori Pauli, Glasgow: Street Level Photography Gallery & Workshop, 1994, n.p.

20. See Chapter 1 in Vladimir Nabokov, *Transparent Things*.

21. Naomi Rosenblum, A *History of Women Photographers*, New York: Abbeville Press, 1994, p 383.

22. Sabina Leßmann, "Die Maske der Weiblichkeit nimmt kuriose formen an . . ." (*The Mask of Femininity Takes on Curious Forms*) in *Fotografieren Hieß Teilnehmen: Fotografinnen der Weimarer Republik*, Essen: Museum Folkwang , 1994, p. 272.

23. Joanna Frueh, "Hannah Wilke," in Kochheiser, Thomas H., ed. *Hannah Wilke, A Retrospective*, Essay by Joanna Frueh, Columbia: University of Missouri Press, 1989, p. 12.

24. Ibid, p. 52.

25. David Brittain, "True Confessions: Cindy Sherman Interviewed," *Creative Camera*, vol. 308, (February/March 1991), p. 38.

26. Rosenblum, p. 319.

27. Denise Miller-Clark, *Within This Garden: Photographs by Ruth Thorne-Thomsen*, New York: Aperture, 1993, p. 33.

28. Marion Post Wolcott from a speech to the conference *Women in Photography: Making Connections* in Syracuse in 1986 quoted in Jack Hurley, *Marion Post Wolcott: A Photographic Journey*, Albuquerque: University of New Mexico Press, 1989.

To collect photography is to collect the world.

— Susan Sontag

There is indeed something omnivorous about the act of photography. It offers a way of responding to everything about everything. Like art, it offers, insists or demands that the viewer "open her eyes" and receive what is out there in all its contextual specificity. Photography is about looking around, which is a prerequisite for actually seeing. It operates

Brought to Light

Notes on Babies, Veils, War and Flowers

Lucy R. Lippard

in that place between art and life, where I like to work, and where I am joined by a great many women artists whose focus has been "work" and "home" in the broadest sense—that is, lived experience, familiar but unexplored aspects of daily life. Among the feminist's tasks has been to rehabilitate negative stereotypes of these experiences—to turn them around or restore them to an original positive status. Prime among those stereotypes are maternity, children, women and war, and women's affinity to nature, all of which have been frequently dismissed in recent years as retrograde and "essentialist."

An art collection, perhaps especially a photography collection, documents the ongoing construction of the collector's self-portrait. The chronology of acquisitions can demonstrate whether a collection constitutes a retrospective collage or an evolving incorporative identity like this one. Helen Kornblum acknowledges that she awakened late to feminist issues in photography, so I won't make a case for this being a "feminist" collection. Rather it has a kind of innocence as a valuable group of images by women, perceived as sympathetic by another woman. Recent acquisitions suggest that the ongoing process of collecting is marked by increasing representation of women of color, lesbians, and social activists. And, appropriately, many of the works attest to the fact that identity is not a static property of the self. Kornblum's taste runs to the harmonious rather than the harsh. Her collection documents the transformation of women's photography from images *of* women (although photographed by women) to images *by* women, in which the photographer is speaking not of a transitory moment of insight or formal coincidence, but of the condition of women, a broader context in which she speaks both for herself and for the larger community of women.

I have long used photos as a metaphor in my own writing and in my daily life. Like a photographer, I frame and select in my mind, but instead of following through, I tuck the images away in an "imaginary" file of lived experience, mine and others. Yet it remains a photographic experience, a process of "bringing to light"—or more technically, bringing light into a "dark room," the *camera obscura*, which might stand for the shadows of the visually unexamined. Add to that the images that impress us so much that they never leave the walls of our mind. In this sense, every North American's modern and postmodern experience includes such a "photography collection." Among the images I've filed away for many years is Ruth Orkin's *American Girl in Italy.*

At the height of early feminist anger, a picture of a woman running the gamut of gestures and comments by men might have shown the woman turning and raging at her tormentors, or at the very least flipping them a finger. (In 1972 Laurie Anderson "shot back" at the men who accosted her in a photo series that was relatively gentle and humorous, but made its point by making the aggressors look foolish.) The beauty of Orkin's picture, taken in 1951,

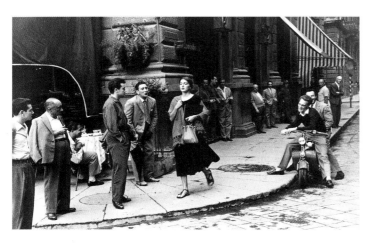

Ruth Orkin
American, 1921–1985
American Girl in Italy, 1951
No.8

is the grace and dignity with which the woman endures a humiliating (not flattering) situation. She neither slinks by, ashamed, nor lets it infuriate her, nor smiles coyly, playing temptress and tease. She raises her head haughtily (but lowers her eyes in distress); she holds her purse in front of her in an unnatural position; is she afraid it will be grabbed? is her purse a symbol for her body which is also in danger of being grabbed?

Of course the fifties were the fifties. I have seen this image described as harmless and charming, but I was an American girl in Italy in the fifties too, and I remember such experiences with horror; they were probably among my earliest nudges toward a feminist consciousness. I have always considered this picture one of the great feminist photographs, for its constraint as well as for its image of female beauty and pride under adverse circumstances. If feminist photography is a weapon against sexism, this is heavy artillery which must call up a visceral response in most women, whatever their politics.

From the beginning of the "second wave" of feminism, which began around 1966 and hit the art world in 1969–70, representation of and by women in words and images has been a core issue. The stereotypical images of women as saints, earthmothers, or sex objects were immediately under attack. Women artists began to analyze, resist, and replace the clichés. It was abundantly clear that women artists had to make their own images of themselves and resurrect those by women in the past that had been erased by a patriarchal culture in favor of submissive, nurturing, childlike, heterosexually erotic clichés. This project was particularly urgent for women of color, who had been doubly suppressed. As in the other arts, women photographers were generally excluded from the upper echelons of the "art world," though some did well enough until they began to deal directly with the mainstream's taboos—"women's imagery" and their own female identities.

During the decade in which I concentrated my energies almost exclusively on women's art (1970–1980), I wrote very little about women's photography, aside from the photographic components of "conceptual art," "land art," and performance. It was only around 1979, when my political work led me to examine documentary photography with more intensity, that I began to wonder why. The answer may be provided by Catherine Lord in a lengthy 1980 article that I recently re-read, on the dilemmas of organizing a women's photography show ("The Image Considered," curated with Nancy Gonchar); I recommend it as a good synopsis of attitudes prevalent in the seventies. Lord's text is dated, but not outdated,

and she observes that the feminist-oriented photography being considered for her show was less audacious than that being done in other mediums—"so mild, on the whole, so restrained about anger, so gently satirical."[1]

I wonder now if photography itself diffuses anger because of its inherent distance from both subject and product. (This might even be said of work like Donna Ferrato's searing investigations of domestic violence, or Barbara Kruger's coolly confrontational "broadsides.") Are emotions defused when technology intervenes? Is the old expressionist credo of heart to mind to hand revalidated? This "remote syndrome" may also be reflected in the language currently used about photography. In the last two decades, "images" have become "representations"—a harder, more pseudo-objective term that should not be applied to all images (many remain presentations).

"Representation" implies mediation. The term is determined by mass media as well as by photographic mediums, both of which can distort and exploit. The construction of identity through representation of the body has been almost exclusively the prime theme of feminist photography in the eighties and nineties, to a point where the discourse has become convoluted and repetitive. Theory usually comes after the fact, after the immediate visual/emotional impact of the image, providing a way of investigating the pleasure or pain, boredom or provocation, and ideas in the intellectual air, past and present. At its core, however, are important insights into practice. Feminist theorists have suggested that women have been distanced from their own bodies by the intervention of the mass media, equated with the "authority" of the dominant culture. The question is how, or whether, the camera in the hands of one's self or another woman has changed the way people see women's bodies.

Despite having been awarded the dubious honor of arthood, all photography is still perceived as having one foot in the real world, a toe in the chilly waters of verisimilitude, no matter how often it is demonstrated that photographs can and do lie. Photographers find themselves directly in competition with the mass media's misrepresentations of women. So the photographic terrain is particularly contested from a political viewpoint. At the same time, that inevitable, but queasy, relationship to the real and to realism remains unresolved, permitting photographers an exit from the confines of "high art," even as they aspire to its laurels.

Technology itself has been presented as an obstacle to women's prominence in photography, although this is hardly justified. From the earliest days, most women printed their own work; Margaret Bourke-White was as obsessed with monumental technology as Fernand Léger; pioneer women photographers developed their prints in the most adverse circumstances (I think of Kate Cory, living in a Hopi village, developing her pictures with rainwater.) In fact, by 1910, women made up 20 percent of the photographic work force in America and were participating in all the schools and movements. Many learned their trade and put it to use within the Settlement House context. Anne Wilkes Tucker, who wrote the groundbreaking *The Woman's Eye*[2] in 1973, observes that photographic *practice* at least was widely available to women, who, like men, learned the technology from manuals and

apprenticeships: "Because the medium was never appropriated by academies," the field was wider open in its earlier days. "Women's representation and the acknowledgement of their contributions declined or disappeared only when later historians evaluated a movement," as in Beaumont Newhall's comprehensive *History of Photography* which included only ten women.[3] The same might be said of the feminist art movement as a whole, which was so marginalized (and so resistant) in the earlier years that anything seemed possible. Tucker herself specialized in photography, and then women's photography, for similar reasons: "I chose to be a photohistorian because what we don't know about photography's history is greater than what we know . . . I perhaps knew instinctively that with so much available territory, a woman stood a better chance of staking claims."[4]

Interestingly, Native American photography critic Theresa Harlan has said something similar in regard to contemporary Indian photography: not being associated with the hand-wrought traditional Native arts appropriated by anthropologists and art historians, photography could slip out of aesthetic prisons.[5] A Native American photographer in the Kornblum collection—Hulleah Tsinhnahjinnie (Creek/Seminole/Navajo)—is an escape artist par excellence, irreverently reversing non-Indian images of Indian women.

Even twenty-five years later, there are few major collections that concentrate on women's photography. Each has its own character. The Kornblum collection, for instance, is rich in faces. *Defining Eye* is characterized by a preponderance of portraits, self-portraits, and images that could pass as portraits even when the subject is unidentified or obviously unknown to the photographer. ("Who's defining whom?" might be the question the curator is asking.) Among them are a large number of pictures of mothers and children, and children alone. These are subjects that challenge us to look with fresh eyes, since they are so deeply entangled with the most insidious historical stereotypes of gender and social roles. Since the 1970s, a few women artists have tried to demythologize the mother-child relationship without (literally) throwing the baby out with the bathwater. Simple as that may sound, it took some courage, since women artists with children (or even husbands and lovers) were considered "part-time" artists and therefore unworthy of artworld fame and fortune, a bias that has not entirely disappeared in the interim.[6]

The Kornblum collection ranges from the general—a wonderfully workaday picture of a 1900 schoolroom by Frances Benjamin Johnston (far less stylized than her better known Hampton Institute series) and Marion Post Wolcott's inclusion of children on their mothers' laps as part of a community, in her 1940 picture of a crowded Vermont town meeting—to the specific, where context must often be guessed at or read through the faces.

Dorothea Lange's unposed 1938 portrait of a weary mother and tousled child lacks the rhetorical force of her famous 1936 picture of the destitute migrant worker and her children, but it is affecting in its very casualness, its "reality." The pair are in transit during hard times; their troubles are etched in the mother's kind and perhaps resigned expression; the child is temporarily calmed with a cracker. The mysterious body-shaped pile in front, which the mother touches protectively, could be baggage, a sleeping child, even a corpse. This is an

Dorothea Lange
American, 1895–1965
Mother and Child, San Joaquin Valley, 1938
No. 3

Nell Dorr
American, 1893/5–1988
Mother and Child, 1940s
No. 33

Diane Arbus
American, 1923–1971
Loser at a Diaper Derby, 1967
No. 11

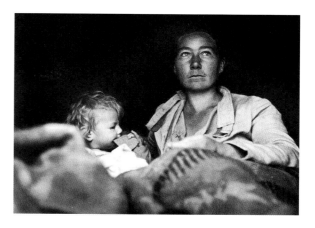

image of mother and child enmeshed in life, a loving relationship tenuously surviving economic hardship.

The apparent idealization of this relationship in Nell Dorr's contemporary *Mother and Child* offers a striking contrast. (It has also been tellingly titled *Happiness.*) Yet on second glance, the beatific subject, the comforting intimacy of close-up expanses of soft fabric and baby flesh are offset by the fleeting quality of the mother's smile, the baby's doubtful expression, and the deep shadows at the right, which cast over the whole image an aura of protection from danger as much as sensual love. (And in fact, tragedy is part of the photographer's biographical background.)

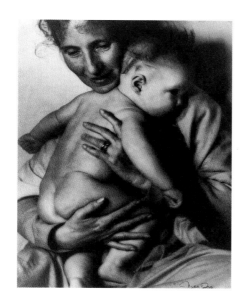

Diane Arbus's truly distressed baby, made still sadder by the title—*Loser at a Diaper Derby*—is for me the most tragic mother and child image here, even more so, for some reason, than those showing children of poverty and displacement. The mother is merely a shadow, an undefined head, distant and somehow ominous. The devastated child seems to be pleading for mercy. This is Arbus at her most compassionate, a startling photo that totally transcends the saccharine "crying baby" cliché and takes it into darkness.

The Lange, the Dorr and the Arbus do not represent opposing views of the mother-child relationships so much as its different facets. Compared to 1980s color prints by Sandra Haber and Lorie Novak, they are period pieces. In these two recent works, montage techniques are employed to reflect the emotional layers and complexity. Haber flanks the mother with her children (or traps her between them), but any comforting symmetry is overpowered by a sense of claustrophobic confusion. In her complex self-portrait, Novak pairs the mother (her own) and child (herself, face blotted by a tentacle-like shadow), while her adult self stands alone at the left. Between and over all of these lies the "central image"—a suggestive vaginal V-shape in red and white fabric. Here the anxiety and alienation that has become

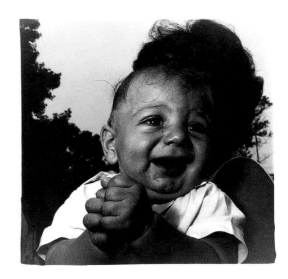

inherent in the notion of the "nuclear family" (also the subject of Sandy Skoglund's *Atomic Love*) is brought to the foreground, replacing the poverty-driven frustrations and vulnerable sensuality of motherhood highlighted in the Lange and the Dorr.

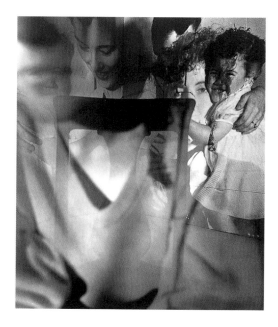

Portraits of children are notoriously endearing and therefore disdained by the postmodernist sensibility. For instance, Nancy Linn, a New York photographer (not in this collection) who for years has photographed youthful parents and their babies for a Bellevue Hospital program, has always found it difficult to exhibit her work due to its subject matter: "Is that your child?" curators ask; an affirmative answer would be the kiss of death. So the "portfolio" of children's pictures and portraits within Kornblum's collection is thought-provoking. Children are more "themselves" and communicate more about their lives in candid shots. When posed self-consciously for portraits, they tend to live up to social expectations and get "cute." We don't even know the name of the subject in Esther Bubley's touching but unsentimental shot of a little African-American girl in a bus

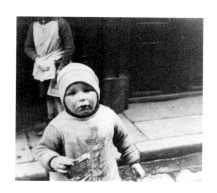

station, all dressed up, holding her mother's purse, and looking very worried. But all kinds of possible narratives can be woven around her, as they can around Graciela Iturbide's *Mujercita (Little Woman),* a 1980s picture that might also have been taken in the Depression. A tiny Mexican girl holds tight to a puppy as she strides purposefully ahead in her oversized cowboy boots; her somber and determined expression might reflect that of her own mother as she struggles to survive. I am clearly not of

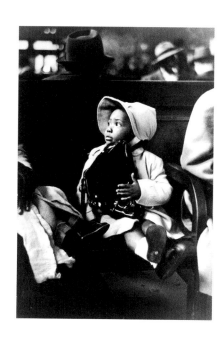

the formalist school that believes that "what you see is what you get," that images should not be "read into." A good image, it seems to me, is one that evokes and welcomes interaction with the viewer, setting up a three-way relationship: the initial encounter (often fleeting, as in this case) between the subject and the photographer, and the subsequent ones that include the viewers.

Mary Ellen Mark's heartrending *Tiny* shows a young girl dressed up for Halloween in a veiled

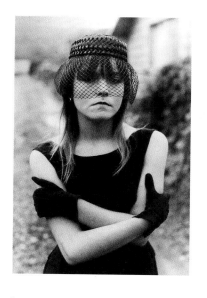

hat, basic black "cocktail dress" and black gloves. (She has not been disguised for the photograph, but has imagined herself.) Her forlorn toughness suggests she is one of the street children Mark has famously photographed, and therefore the sexy and prematurely adult "costume" must be regarded with apprehension rather than fond tolerance. The veil is a symbol of virginity and widowhood, as well as eroticism; Tiny screens her face as she tentatively presents her body.

Consuelo Kanaga's St. Croix schoolgirl is around the same age. Although still dressed as a child in her straw hat and school uniform, she projects a more positive maturity. Arms folded, staring pensively into the distance towards what may be a less than rosy future, she presents a portrait of independence and introspection. Such pictures seem relatively straightforward, but when they are this powerful, they too call in unseen contexts, implying much more than they actually depict.

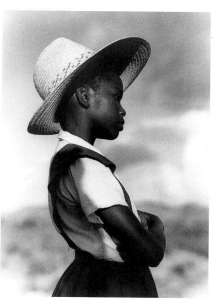

The collection includes several pictures of children disguised or hiding, either from the camera or from adult scrutiny. Ellen Auerbach's 1929 *Portrait of Goggi* is a small boy seen from the back, face almost hidden, which may say more about him than a full-face portrait could. (In the early thirties, Auerbach, as a part of the studio ringl + pit, specialized in photographing children.) Ilse Bing's little naked girl sitting on the edge of a bathtub hides her face with a washcloth, already socialized into embarrassment and awareness of her body. (I pair this in my mind

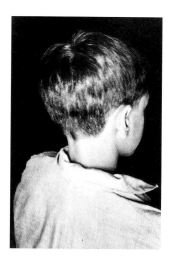

with the old woman napping under a newspaper in Inge Morath's *Siesta of a Lottery Ticket Vendor, Plaza Mayor, Madrid,* 1923.) In Helen Levitt's lively kids in Halloween masks (1940), the innocence suggested by their awkward and self-conscious stances overcomes the desired "evil" (or at least mystery) of their home-made masks. Segue to Marie Cosindas's wall of masks combining naturalistic faces and fantastic ones, reality and illusion; and then to Kati Horna's doll parts. (Made in 1933, this apparently predates Hans Bellmer's perverse rearrangements of dismembered dolls.) Horna's doll's legs have been transported, but her head and hands are intact and her alert

expression counters the vacuity of most doll faces. A doll (instead of a guy) using a doll in her art, and a doll that does not quite resemble a good little girl, predicts contemporary works like Laurie Simmons's dancing petit fours or Skoglund's satirical Barbies—who are not only *at* the beach (made of french fries) but blend culture with nature to *become* the beach—and get walked on, or perhaps eaten alive.

Although Skoglund's intention may have been to parody the conflation of woman with nature, two earlier works took that affinity seriously. Anne Brigman's heartfelt picture of

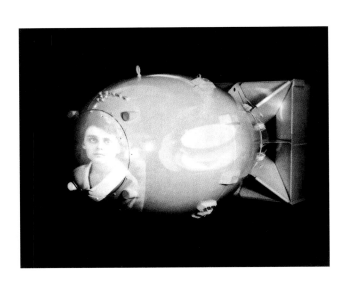

two women blending with a tree and the elements—her 1912 *The Heart of the Storm*—may seem impossibly melodramatic today, but it prefigures such passionate identification with natural forces like Ana Mendieta's *Birth*, documenting an earth piece in which woman gives birth to herself as a primal island.

Feminist portraits and self-portraits include both "likenesses" of individuals and individuals likening themselves to collective identities. The latter tend to be more analytical and socially connected than their historical counterparts. Meridel Rubenstein's *Fatman with Edith* removes the portrait from the parlor and thrusts it into the global landscape. The superimposition of a sweet woman's face on the bomb that devastated Hiroshima is part of her impressive collaborative intermedia installation *Critical Mass,* in which complex social portraits are drawn of Edith Warner, an Anglo woman entwined in the lives of San

Ildefonso Pueblo and the Los Alamos laboratory in the early 1940s. The lethal weapon's ironically breast-like form (a penis foreshortened) offers a bizarre mount for the anxious, intelligent face that becomes its "figurehead," as in ancient warships.

Anne Noggle's portrait of Shirley Condit deGonzales is the inverse of Rubenstein's work. Although the expression on deGonzales's face closely resembles that on Warner's, her pose is awkward, wary, bordering on the absurd. This woman who was a pilot in World War II has been disempowered. She is in civil-

ian drag, wearing her wings, but deprived of flight, dressed up for her portrait, and not enjoying it; she clenches one fist and clings to a cigarette, and to her dignity. This pair of

Gertrud Arndt

German, born 1903

Self-Portrait with Veil, 1930

No. 68

Claude Cahun

French, 1894–1954

M.R.M. (Sex), 1936

No. 66

images suggests that powerful women are powerless against war. Martha Rosler turns the tables with her Vietnam era series *Bringing the War Home: House Beautiful,* originally deployed as public protests against the war. Military personnel from another world invade the secure domestic terrain of the American middle class. We know, in retrospect, that those kitchens were never the same again; the politics of the Antiwar Movement led directly into the Women's Movement.

* * *

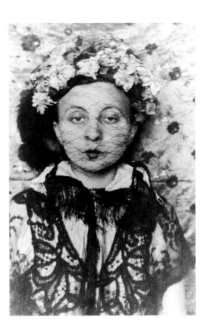

The Kornblum collection provides a variety of portraits and self-portraits as icons of feminist self-discovery, rebellion, vulnerability, and even self-loathing. The range is suggested by five "hand portraits." On the one end of the scale is the languidly passive 1928 hand portrait of the actress Jenny Burney by Germaine Krull, enigmatically covering another, anonymous, hand. It contrasts with active images like Alma Lavenson's. She portrayed herself (in 1932) as her hands, strong and capable, adjusting the lens on her camera. This is a woman in control, as is Imogen Cunningham's 1935 portrait of the equally competent hands of an unseen harpist, in which the woman's invisible body is suggested by the powerful arabesques of the double

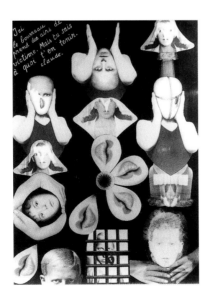

harp. Eileen Cowin provides a potentially tragic image of a relationship in her *Dripping Hands, Praying Mantis* (1994): a man allows water to escape through his fingers while the insect hovers at a distance, readied to cross the black space that separates the two. Lorna Simpson pairs fragments of family album-type photographs —all centered on hands— with fragments of text that seem to tell a romantic or dramatic narrative.

Feminist photography frequently centers on self-portraiture, or knowing one's self as a key to understanding the world that helped form it. Self-portraiture is no longer a pleasant primping trip to the mirror or even a melancholy introspection. Photographer Clarissa Sligh sees it as an exercise in survival and healing; when asked to write about her self-portraits in the context of a racist and sexist society, she said this was "asking me to put myself on the operating table and to perform the operation at the same time"—a statement that might have been made by Frida Kahlo, who is pictured by her friend Lola Alvarez Bravo as proud and calm, but surrounded, literally, by her bed of pain.

Gertrud Arndt (in 1930) seems to caricature herself and "femininity," her mouth pursed and painted like a doll's, the floral patterns of vest and background echoed by her hat, lace and veil making both face and body enigmatic. (Or is this a serious attempt to identify with nature, as in Ruth Thorne-Thomsen's *Señora Flora?* It seems more likely that Arndt was suggesting that nature is a cover for darker forces, as in Olivia Parker's *At the Edge of the Garden.*) Claude Cahun's 1936 collage *M.R.M. (Sex)* tries on the masks European society provides for women, some of them in flower-form, and finds them lacking; her fragmentation of self through a collage aesthetic implies imprisonment and suffocation in the process. As a woman who loved women she was unable to "show her face," yet her sexual imagery was overt and contemporary.

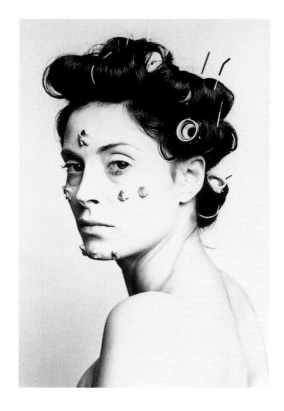

Like Arndt and Cahun, Hannah Wilke and Marta María Pérez Bravo "veil" themselves with symbols of pain. Wilke's *S.O.S. Starification Object Series* (1974) shows a beautiful woman

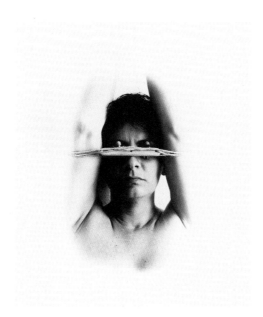

(her hair in fat curlers, her face "scarred" by chewing gum vaginas) whose beauty is being manipulated by society and by her own conditioned experience. Her gaze is both level and wary. Pérez, on the other hand, cannot see with her own eyes: *No vi con mis propios ojos.* She masks herself with symbols of bondage and replaces her eyes with tiny baby figures representing her twins, telling a personal story that extends into a collective history of women and mothers. Ownership —of faces, bodies, lives—is contested in both of these self-portraits.

Cindy Sherman and Carrie Mae Weems veil, or shield, themselves by becoming others, out of reach behind actual or implied disguises. Although Sherman is the protagonist in all of her photographs, she herself, her feelings, her life, even her face, are virtually invisible. In this image from her *History Portraits* series, she makes "classical beauty" both homely and endearing as a commentary on portraiture (and perhaps portraiture of the rich). Despite the extreme violence of many of her responses to women's sexual portrayal and betrayal, there is always a curious element of

Cindy Sherman
American, born 1954
Untitled, from the *History Portraits* series,
1989
No. 69

Carrie Mae Weems
American, born 1953
Untitled, 1990
No. 72

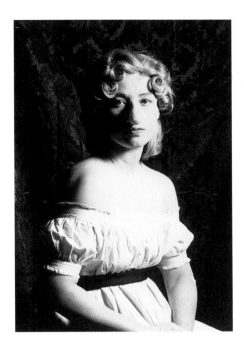

compassion in Sherman's work that may be a clue to the real self-portraits hidden beneath the simulations.

While Weems's work has autobiographical undertones and she appears as herself acting the role of someone like herself, she too has distilled her lived experience within a fictional framework. Here the mother, however independent, is creating a model in complicity with society's image of how women should be. Or perhaps the protagonist and her daughter are literally "making themselves up" in defiance of social expectations of black women.

* * *

As is clear from the Kornblum collection, women photographers have long sought the defining image of self and feminine experience. Feminism provided a political context for these examinations, both internally (for the artist) and externally (for the viewers). Even the apparently "tamest" of these works force those artists and viewers to confront the politics they have preferred not to think about. Along with its more senti-

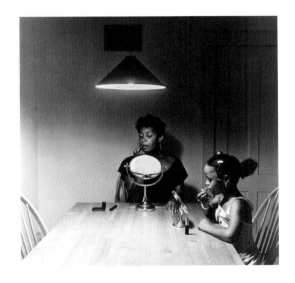

mental and analytical functions, photography has lent itself to rebellion. "I always thought of photography as a naughty thing to do—that was one of my favorite things about it," said Diane Arbus.[7]

Notes *Thanks to Meridel Rubenstein for lending me good books and giving good advice.*

1. Catherine Lord, "Women and Photography: some thoughts on assembling an exhibition," *Afterimage*, January, 1980, p. 6–13. (This is decidedly not the case of the "Queer" photography about which Lord currently writes.)

2. Anne Tucker, *The Woman's Eye*, New York: Alfred A. Knopf, 1976. See also *Women of Photography: An Historical Survey*, San Francisco: San Francisco Museum of Art, 1975, curated by Margery Mann and Anne Noggle; *In/Sights: Self Portraits by Women*, compiled by Joyce Tenneson Cohen, Boston: David Godine, 1978; Andrea Fisher, *Let Us Now Praise Famous Women: Women Photographers for the U.S. Government 1935 to 1944*, London: Pandora, 1987; and Naomi Rosenblum: *A History of Women Photographers*, New York: Abbeville, 1994. Diane Neumaier's anthology cited in the next note is an invaluable addition to this list.

3. Anne Wilkes Tucker, "Foreword," in Diane Neumaier, ed., *Reframings: New American Feminist Photographers*, Philadelphia: Temple University Press, 1995, p.ix. I did the index to the fourth edition of the Newhall book in 1964, and didn't even notice the scarcity of women; ten years later I would have been outraged.

4. Anne Wilkes Tucker, *Reframings*, p. ix.

5. Theresa Harlan, "A Curator's Perspective: Native Photographers Creating a Visual Native American History," *Exposure*, Fall 1993, p. 13.

6. Pregnancy and parenthood in the first person were most notably investigated in the seventies in major works by two American artists/photographers living in England: Mary Kelly's *Post Partum Document* and Susan Hiller's *Ten Months*.

7. Diane Arbus, quoted in Susan Sontag, *On Photography*, New York: Penguin Books, 1977, p. 12.

Selected Bibliography

General

de Zegher, M. Catherine, ed. *Inside The Visible/An Elliptical Traverse of 20th Century Art. In, Of, and From the Feminine*. Boston: Institute of Contemporary Art, 1996.

Eskildsen, Ute, ed. *Fotografieren Hieß Teilnehmen: Fotografinnen der Weimarer Republik*. Essen: Museum Folkwang, 1994.

Lippard, Lucy, ed. *Partial Recall*, New York: The New Press, 1992.

Moutoussamy-Ashe, Jeanne. *Viewfinders: Black Women Photographers*. New York: Dodd, Mead, and Company, 1986.

Neumaier, Diane, ed. *Reframings: New American Feminist Photographies*. Philadelphia: Temple University Press, 1995.

Rosenblum, Naomi. *A History of Women Photographers*. New York: Abbeville Press, 1994.

Solomon-Godeau, Abigail. *Photography at the Dock: Essays on Photographic History, Institutions, and Practices*. Minneapolis: University of Minnesota Press and Regents of the University of Minnesota, 1991.

Sullivan, Constance, ed. *Women Photographers*. New York: Harry N. Abrams, 1990.

Tucker, Anne. *The Woman's Eye*. New York: Alfred A. Knopf, 1973.

Williams, Val. *Women Photographers: The Other Observers, 1900 to the Present*. London: Virago Press, 1986.

Berenice Abbott

McCausland, Elizabeth and Berenice Abbott. *New York in the Thirties: As Photographed by Berenice Abbott*. New York: Dover Publications, 1973.

Van Haaften, Julia, ed. *Berenice Abbott Photographer: A Modern Vision: A Selection of Photographs and Essays*. New York, New York Public Library, 1989.

Lola Alvarez Bravo

Grimberg, Salomon. *Lola Alvarez Bravo: The Frida Kahlo Photographs*. Dallas, Texas: Society of Friends of Mexican Culture; New York: Distributed by D.A.P., 1991.

Diane Arbus

Arbus, Doon and Marvin Israel, eds. *Diane Arbus*. Millerton: Aperture, 1972.

Arbus, Doon and Yolanda Cuomo, eds. *Untitled/Diane Arbus*. New York: Aperture, 1995.

Bosworth, Patricia. *Diane Arbus: A Biography*. New York: Knopf, 1984.

Gertrud Arndt

Arndt, Gertrud. *Gertrud Arndt*. Berlin: Das Verborgene Museum, 1994.

Leßmann, Sabina. "Die Maske der Weiblichkeit nimmt kuriose formen an..." (*The Mask of Femininity Takes on Curious Forms*). In *Fotografieren Hieß Teilnehmen: Fotografinnen der Weimarer Republik*. Essen, Museum Folkwang, 1994.

Tina Barney

Barney, Tina. *Friends and Relations: Photographs*. Washington: Smithsonian Institution Press, 1991.

Rimanelli, David. "People Like Us: Tina Barney's Pictures." *Artforum* 31 (October 1992), 70–73.

Rubinstein, Raphael. "Lifestyles of the Protestant Bourgeoisie: The Photographs of Tina Barney." *Arts Magazine* vol. 62 (April 1988), 50–52.

Uta Barth

Barth, Uta. At the Edge of the Decipherable: Recent Photographs by Uta Barth. Los Angeles: Museum of Contemporary Art, 1995.

Marilu, Knode. "Uta Barth in Conversation with Marilu Knode." Artlies 7 (June/July 1995), 30–32.

Pagel, David. "Disposable Diagrams." Artweek 20 (October 14, 1989), 3.

Jessie Tarbox Beals

Alland, Alexander. Jessie Tarbox Beals. First Woman News Photographer. New York: Camera/Graphic Press Ltd., 1978.

Ilse Bing

Barrett, Nancy C. Ilse Bing: Three Decades of Photography. New Orleans: New Orleans Museum of Art, 1985.

Bing, Ilse. Ilse Bing. Paris 1931–1952. Paris: Paris-Musées, Musée Carnavalet, 1987.

Margaret Bourke-White

Bourke-White, Margaret. Portrait of Myself. New York: Simon and Schuster, 1963.

Brown, Theodore M. Margaret Bourke-White, Photojournalist. Ithaca: Andrew Dickson White Museum of Art, Cornell University, 1972.

Caldwell, Erskine and Margaret Bourke-White. You Have Seen Their Faces. New York: Modern Age Books, 1937.

Callahan, Sean, ed. The Photographs of Margaret Bourke-White. Boston: New York Graphic Society, 1975.

Goldberg, Vicki. Margaret Bourke-White: A Biography. New York: Harper & Row, 1986.

Anne W. Brigman

Ehrens, Susan. A Poetic Vision: The Photographs of Anne Brigman. Santa Barbara: Santa Barbara Museum of Art, 1995.

Heyman, Therese Thau. Anne Brigman: Pictorial Photographer, Pagan Member of the Photo Secession. Oakland: The Oakland Museum, 1974.

Esther Bubley

"Take A Bus: Photographs by Esther Bubley." Minicam Photography, vol. 7, no. 10 (June 1944), 58–61.

Ellis, Jacqueline. "Esther Bubley. FSA Documentarist." History of Photography, vol. 20, no. 3 (Autumn 1996), 265–270.

Fisher, Andrea. Let Us Now Praise Famous Women: Women Photographers for the U.S. Government 1935–1944. London and New York: Pandora Press, 1987.

Debbie Fleming Caffery

Caffery, Debbie Fleming. Carry Me Home: Louisiana Sugar Country Photographs by Debbie Fleming Caffery. Washington, D.C. and London: Smithsonian Institution Press, 1990.

Claude Cahun

Monahan, Laurie J., "Radical Transformations: Claude Cahun and the Masquerade of Womanliness" in M. Catherine de Zegher, ed., Inside The Visible/An Elliptical Traverse of 20th Century Art. In, Of, and From the Feminine. Boston: Institute of Contemporary Art; Cambridge, Massachusetts: MIT Press, 1996.

Lichtenstein, Therese. "A Mutable Mirror: Claude Cahun." Artforum. (April 1992), vol. 30, 64–67.

Marie Cosindas

Feldman, Susan, ed. Marie Cosindas, Color Photographs. Boston: New York Graphic Society, 1978.

Eileen Cowin

Figurative Contexts: An Exhibition of Photographs in Color. Terre Haute: Indiana State University, 1983.

Cowin, Eileen. *Eileen Cowin.* Tokyo: Gallery Min, 1987.

Cowin, Eileen. Unpublished artist statement, 1997.

Kundera, Milan. *Immortality.* New York: Grove and Weidenfeld, a Division of Grove Press, 1990.

Imogen Cunningham

Lorenz, Richard. *Imogen Cunningham: Ideas Without End: A Life in Photographs.* San Francisco: Chronicle Books, 1993.

Rule, Amy, ed. *Imogen Cunningham: Selected Texts and Bibliography.* Boston: G.K. Hall, 1992.

Aya Dorit Cypis

Briggs, Patricia and Diane Mullin. *Through the Body: Embodying the Self* (exhibition brochure). Minneapolis: Frederick R. Weisman Art Museum, 1996.

Medvedow, Jill. *Concealing the Reveal: Disclosure in the Art of Dorit Cypis, The Body in the Picture* (exhibition brochure). Boston: Isabella Stewart Gardner Museum, 1993.

Nell Dorr

Dorr, Nell. *Mother and Child.* New York: Harper Brothers, 1954.

Mayer, Grace M. "Nell Dorr." *Infinity* 12 (December 1963), 5–14, 24–25, 27.

Mitchell, Margaretta K. "Nell Dorr." *Popular Photography,* 76 (March 1975), 98–107, 114–115.

Barbara Ess

Ess, Barbara. *Barbara Ess. I Am Not This Body.* New York, Curt Marcus Gallery, 1991.

Ess, Barbara. *Barbara Ess.* New York: Curt Marcus Gallery; Galería la Maquína Española, 1990.

Krane, Susan. *Art at the Edge: Barbara Ess.* Atlanta: High Museum of Art, 1992.

Flor Garduño

Garduño, Flor. *Witnesses of Time: Flor Garduño.* New York: Thames and Hudson, 1992.

Laura Gilpin

Gilpin, Laura. *The Enduring Navaho.* Austin: University of Texas Press, 1968.

Sandweiss, Martha A. *Laura Gilpin, An Enduring Grace.* Fort Worth, Texas: Amon Carter Museum, 1986.

Nan Goldin

Goldin, Nan. *The Ballad of Sexual Dependency.* New York: Aperture, 1986.

Goldin, Nan. *The Other Side.* New York: Scalo Publishers, 1993.

Jan Groover

Kismaric, Susan. *Jan Groover.* New York: The Museum of Modern Art, 1987.

Sullivan, Constance, ed. *Jan Groover: Photographs.* Boston, Little, Brown and Company, a Bullfinch Press Book, 1993.

Sullivan, Constance, and Susan Weiley, eds. *Pure Invention—The Table Top. Still Life: Photographs by Jan Groover.* Washington: Smithsonian Institution Press, 1990.

Florence Henri

du Pont, Diana C. *Florence Henri, Artist-Photographer of the Avant-Garde.* San Francisco: San Francisco Museum of Modern Art, 1990.

Henri, Florence. *Florence Henri.* New York: Martini and Ronchetti, 1974.

Candida Höfer

Hofleiter, Johanna. "Candida Höfer," *Forum International*, no. 16 (January/February 1993), 92–96.

Magnani, Gregorio. "Unassuming Photography." *Raume/Spaces: Candida Höfer*. Frankfurt: Portikus, 1992.

Kati Horna

Krinsky, Garcia and Emilia Cecilia. *Kati Horna: Recuento de un Obra*. Mexico: Fonda Kati Horna CENIDIAP-INBA, 1995.

Graciela Iturbide

Binford, Leigh. "Graciela Iturbide: Normalizing Juchitán." *History of Photography*, vol 20, no. 3 (Autumn 1996), 244–249.

Connor, Celeste. "Images of Identification: Encountering Difference, Four Mexican Photographers: Falkirk Cultural Center, San Rafael, CA." *Artweek*, 24 (August 19, 1993), 18.

Fusco, Coco. "Essential Differences: Photographs of Mexican Women." *Afterimage*, 18 (April 1991), 11–3.

Poniatowska, Elena. *Juchitán de las Mujeres*. Mexico City: Ediciones Toledo, 1989.

Lotte Jacobi

Jacobi, Lotte. *Lotte Jacobi*. Beverly Hills: Gallery of Photography, 1986.

Wise, Kelly, ed. *Lotte Jacobi*. Danbury: Addison House, 1978.

Frances Benjamin Johnston

Doherty, Amy S. "Frances Benjamin Johnston 1864–1952" *History of Photography*, 4 (April 1980), 97–111.

Johnston, Frances Benjamin. *The Hampton Album: 44 Photographs*. New York: Museum of Modern Art; Garden City, New York: Doubleday, 1996.

Consuelo Kanaga

Kanaga, Consuelo. *Photographs, A Retrospective*. New York: Blue Moon Gallery, Lerner-Heller Gallery, 1974.

Millstein, Barbara Head. *Consuelo Kanaga: An American Photographer*. Brooklyn: The Brooklyn Museum; Seattle: The University of Washington Press, 1992.

Gertrude Käsebier

Homer, William Innes. *A Pictorial Heritage: The Photographs of Gertrude Käsebier*. Wilmington: Delaware Art Museum, 1979.

Michaels, Barbara L. *Gertrude Käsebier: The Photographer and Her Photographs*. New York: Harry N. Abrams, Inc., 1992.

Germaine Krull

Bouqueret, Christian. *Germaine Krull, Photographie 1924–1936*. Arles: Le Musée Reattu, 1988.

Krull, Germaine, *Fotografien, 1922–1966*. Cologne: Rheinland Verlag, 1977.

Dorothea Lange

Coleman, A. D. "Letter from New York #73." *Photo Metro*, vol 14, issue 139, 1996.

Lange, Dorothea. *Dorothea Lange: Photographs of a Lifetime*. Essay by Robert Coles. Millertown: Aperture, 1982.

Heyman, Therese Thau. *Dorothea Lange: American Photographs*. San Francisco: San Francisco Museum of Modern Art, Chronicle Books, 1994.

Partridge, Elizabeth, ed. *Dorothea Lange: A Visual Life*. Washington: Smithsonian Institution Press, 1994.

Alma Lavenson Ehrens, Susan. *Alma Lavenson Photographs*. Berkeley: Wildwood Arts, 1990.

Lavenson, Alma. *Alma Lavenson*. Riverside: California Museum of Photography, 1979.

Annie Leibovitz Leibovitz, Annie. A*nnie Leibovitz Photographs*. New York: Pantheon; Rolling Stone, 1983.

Leibovitz, Annie. A*nnie Leibovitz: Photographs, 1970–1990*. New York: Harper Collins, 1991.

Helen Levitt Levitt, Helen. A *Way of Seeing*. New York: Horizon Press, 1981.

Phillips, Sandra. *Helen Levitt*. San Francisco: San Francisco Museum of Modern Art, 1991.

Dora Maar Chadwick, Whitney. *Women Artists and the Surrealist Movement*. New York: Thames and Hudson, 1985.

Krauss, Rosalind and Jane Livingston. *L'Amour Fou, Photography and Surrealism*. With an essay by Dawn Ades. Washington, D.C.: The Corcoran Gallery of Art and New York: Abbeville Press, 1985.

Mary Ellen Mark Fulton, Marianne. *Mary Ellen Mark: 25 Years*. Boston: Little, Brown, and Company, 1991.

Mark, Mary Ellen. *The Photo Essay: Photographs by Mary Ellen Mark*. Washington: Smithsonian Institution Press, 1990.

Mark, Mary Ellen. *Streetwise*. Photographs by Mary Ellen Mark. New York, 1988.

Margrethe Mather *Margrethe Mather*. "A History of Women Photographers." The Archive, no. 11. Tucson: The Center for Creative Photography, University of Arizona, 1979.

Ana Mendieta Rio, Petra Barreras del, and John Perreault, A*na Mendieta: A Retrospective*. New York: New Museum of Contemporary Art, 1987.

Annette Messager "Annette Messager." *Aperture*, 130 (Winter 1993), 48–53.

Rochette, Anne and Wade Saunders. "Savage Mercies." *Art in America*, 82 (March 1994), 78–83.

Wainwright, Lisa. "Life Stilled." *The New Art Examiner*, 23 (May 1996), 18–22.

Lisette Model Thomas, Ann. *Lisette Model*. Ottawa: National Gallery of Canada, 1990.

Tina Modotti "Tina Modotti: Photography as a Weapon." *History of Photography*, 18 (Autumn 1994), 289.

Constance, Mildred. *Tina Modotti: A Fragile Life*. San Francisco: Chronicle Books, 1993.

Hooks, Margaret. *Tina Modotti: Photographer and Revolutionary*. London, San Francisco: Pandora, 1993.

Lowe, Sarah M. *Tina Modotti: Photographs*. New York: Harry N. Abrams in association with the Philadelphia Museum of Art, 1995.

Lucia Moholy Fiedler, Jeannine, ed. *Photography at the Bauhaus*. Cambridge, Massachusetts: The MIT Press, 1990.

Sachsse, Rolf. *Lucia Moholy: Bauhaus Fotografin*. Berlin: Bauhaus-Archiv, 1995.

Inge Morath Morath, Inge and Margit Zuckriegl. *Inge Morath: Fotografien 1952–1992.* Salzburg: Edition Fotohof in the Otto Muller Verlag, 1992.

Morath, Inge. *Portraits.* New York: Aperture, 1986.

Barbara Morgan Aminco, Leonard N. *The Photographs of Barbara Morgan.* Williamstown, Massachusetts: Williams College Museum of Art, 1978.

Joan Myers Myers, Joan. *Whispered Silences: Japanese Americans and World War II.* Essay by Gary Y. Okihiro. Seattle: University of Washington Press, 1996.

Nelly (Elli Seraïdari) Fotopoulos, Dionissis. *Nelly's.* Athens: The Agricultural Bank of Greece, 1991.

Anne Noggle Noggle, Anne. *For God, Country and the Thrill of It.* College Station: Texas A & M University Press, 1990.

Barbara Norfleet Norfleet, Barbara. *All the Right People.* Boston: Little and Brown, 1986.

Dorothy Norman Norman, Dorothy. *Beyond a Portrait: Photographs by Dorothy Norman and Alfred Stieglitz.* Millerton: Aperture, 1984.

Norman, Dorothy. *Intimate Visions: The Photographs of Dorothy Norman.* New York: International Center of Photography, 1993.

Sonya Noskowiak Bender, Donna, Jan Stevenson and Terence R. Pitts. *Sonya Noskowiak Archive.* Guide Series, No. 5. Tucson: Center for Creative Photography, University of Arizona, 1982.

Sonya Noskowiak. The Archive, No. 9. Tucson: Center for Creative Photography, University of Arizona, 1979.

Lorie Novak du Pont, Diana C., Lorie Novak. *Centric 42* (exhibition brochure). Long Beach, University Art Museum, California State University, 1991.

Noval, Trena. "In Other Worlds: The Work of Ana Mendieta and Lorie Novak." *Camerawork*, 23, no. 2 (Fall/Winter, 1996), 12–16.

Catherine Opie Fergusen, Russell. "Catherine Opie." *Index.* (April 1996), 28–31.

Neumaier, Diane, ed. *Reframings. New American Feminist Photographies.* Philadelphia: Temple University Press, 1995.

Ruth Orkin Bultman, Janis. "Candor and Candids: An Interview with Ruth Orkin." *Darkroom Photography*, 4 (September–October 1982), 18–25, 29.

Hagen, Charles. "Beyond That Single Famous Picture." *The New York Times*, June 2, 1995.

Orkin, Ruth. *A World Through My Window.* New York: Harper and Row, 1978.

Stevens, Nancy. "Ruth Orkin: A Retrospective Look at the Life and Work of a Humanist Magazine Photojournalist." *Popular Photography*, vol. 80 (June 1977), 100–109, 144, 158.

Olivia Parker

Parker, Olivia. *Under the Looking Glass: Color Photographs*. Boston: Little, Brown, 1983.

Parker, Olivia. "Weighing the Planets." *Untitled 44*. Boston: Little, Brown and Company, 1987.

Jane Reece

Brannick, John A. "Jane Reece and Her Autochromes." *History of Photography*, 13 (January–March 1989), 1–4.

Pinkney, Helen L. "Jane Reece Memorial Exhibition: The Wonderful World of Photography." *The Dayton Art Institute Bulletin*, vol. 21, no. 5 (March–April 1963).

Yochelson, Bonnie and Kathleen A. Erwin. *Pictorialism into Modernism: The Clarence White School of Photography*. New York, 1996.

Ursula Richter

Eskildsen, Ute, ed. *Fotografieren Hieß Teilnehmen: Fotografinnen der Weimarer Republik*. Essen: Museum Folkwang, 1994.

Fundacio "La Caixa," ed. *Les dones fotògrafes a la República de Weimar, 1919–1933*. Essays by Atina Grossman, Ute Eskildsen, Hanne Bergius and Ulrike Herrmann. Barcelona: Fundacio La Caixa, 1995.

ringl + pit

ringl + pit, Grete Stern, Ellen Auerbach. Fotografissche Sammlung im Museum Folkwang, Essen, 1993 (exhibition catalogue).

Lavin, Maud. "ringl + pit: The Representation of Women in German Advertising, 1929–33." *Print Collector's Newsletter*, (July/August 1985), 89–93.

Holly Roberts

Roberts, Holly. *Holly Roberts*. San Francisco: The Friends of Photography, 1989.

Martha Rosler

Williams, Val. *Warworks—Women, Photography and the Iconography of War*. London: Virago Press, 1994.

Meridel Rubenstein

Lippard, Lucy. "Philosophical Fallout." *Z Magazine*, vol. 7, no. 4 (April 1994), 52–54.

Rubinstein, Meridel and Ellen Zweig. "Critical Mass." Unpublished artist statement, 1993.

Solnit, Rebecca. "Meridel Rubenstein: Critical Mass." *Artspace*, vol 16, no 4 (July/August 1992), 46–47.

Charlotte Rudolph

Preston-Dunlop, Valerie and Suzanne Lausan, eds. *Shifttanz: A View of German Dance in the Weimar Republic*. London: Laban Center for Movement and Dance; Dance Books, 1990.

Rosenblum, Naomi. A *History of Women Photographers*. New York: Abbeville Press, 1994.

Cindy Sherman

Brittain, David. "True Confessions: Cindy Sherman Interviewed." *Creative Camera*, vol. 308 (February/March 1991), 34–38.

Krauss, Rosalind E. *Cindy Sherman, 1975–1993*. New York: Rizzoli, 1993.

Sherman, Cindy, Peter Schjeldahl, and Lisa Phillips. *Cindy Sherman*. New York: Whitney Museum of American Art, 1987.

Sherman, Cindy. *History Portraits*. New York: Rizzoli, 1991.

Laurie Simmons

Goldwater, Marge. *Past/Imperfect: Eric Fischl, Vernon Fisher, and Laurie Simmons*. Minneapolis: Walker Art Center, 1987.

Simmons, Laurie. *Laurie Simmons: October 21–December 30, 1990, San Jose Museum of Art*. San Jose, California: The San Jose Museum of Art, 1990.

Simmons, Laurie. *Laurie Simmons: Interviewed by Sarah Charlesworth*. Prescott: Art Press, 1994.

Lorna Simpson

Willis, Deborah. "Lorna Simpson." *Untitled 54*. San Francisco: Friends of Photography, 1992.

Wright, Beryl J. *Lorna Simpson: For the Sake of the Viewer*. New York: Universe Publishing; Chicago: Museum of Contemporary Art, 1992.

Sandy Skoglund

Hoy, Anne H. *Fabrications: Staged, Altered and Appropriated Photographs*. New York: Abbeville Press, 1987.

Richardson, Nan. "Sandy Skoglund: Wild at Heart." *ARTnews*, 90 (April 1991), 114–119.

Ruth Thorne-Thomsen

Miller-Clark, Denise. *Within This Garden: Photographs by Ruth Thorne-Thomsen*. New York: Aperture, 1993.

Hulleah Tsinhnahjinnie

Tremblay, Gail. "Reflections on 'Mattie Looks for Steve Biko,' A Photograph by Hulleah Tsinhnahjinnie. In Lippard, Lucy, ed. *Partial Recall*. New York: The New Press, 1992.

Tsinhnahjinnie, Hulleah. Unpublished artist statement, 1997.

Doris Ulmann

Featherstone, David. *Doris Ulmann: American Portraits*. Albuquerque: University of New Mexico Press, 1985.

Ulmann, Doris. *The Appalachian Photographs of Doris Ulmann*. Highlands: Jargon Society, 1971.

Ulmann, Doris. *The Darkness and the Light: Photographs by Doris Ulmann*. Essay by Robert Coles. Millerton, NY: Aperture, 1974.

Margaret Watkins

Beloff, Halla, Joseph Mulholland and Lori Pauli. *Margaret Watkins 1884–1969: Photographs*. Glasgow: Street Level Photography Gallery & Workshop, 1994.

Borcoman, James. *Magicians of Light: Photographs from the Collection of the National Gallery of Canada*. Ottawa: National Gallery of Canada, 1993.

Fulton, Marianne, ed. *Pictorialism into Modernism: The Clarence H. White School of Photography*. Rochester, New York: George Eastman House; Detroit: Detroit Institute of Arts, 1996.

Watkins, Margaret. *Margaret Watkins Photographs, 1917–1930*. Glasgow, 1981.

Watkins, Margaret. "Advertising Photography" *Pictorial Photography in America*, 4 (1926).

Carrie Mae Weems

Kirsh, Andrea, and Susan Fisher Sterling. *Carrie Mae Weems*. Washington, D.C.: National Museum of Women in the Arts, 1993.

Hannah Wilke

Kochheiser, Thomas H., ed., *Hannah Wilke: A Retrospective*. Essay by Joanna Frueh. Columbia: University of Missouri Press, 1989.

Wilke, Hannah. *Intra-Venus*. New York: Ronald Feldman Gallery, 1995.

Marion Post Wolcott Elliott, James, and Marla Westover. *Marion Post Wolcott—FSA Photographs.* Berkeley: University of California Art Museum, 1978.

Hurley, Jack. *Marion Post Wolcott: A Photographic Journey.* Albuquerque: University of New Mexico Press, 1989.

Mariana Yampolsky Brittan, David. "Mariana Yampolsky: Drinking From the Roots" *Creative Camera*, 5 (1989), 9, 16–21.

Connor, Celeste. "Images of Identification: Encountering Difference, Four Mexican Photographers: Falkirk Cultural Center, San Rafael, CA." *Artweek* 24 (August 19, 1993), 18.

Parada, Esther. "Rio de Luz." *Aperture*, 109 (Winter 1987), 71–8.

Yva (Else Simon) Eskildsen, Ute, ed. *Fotografieren Hieß Teilnehmen: Fotografinnen der Weimarer Republik.* Essen: Museum Folkwang, 1994.

Rosenblum, Naomi. *A History of Women Photographers.* Paris, London and New York: Abbeville Press, 1994.

Works in the Exhibition

Berenice Abbott
American, 1898–1991
Gambetta Snuff Shop, NYC,
1935
gelatin silver print
10 x 8 inches
25.4 x 20.3 cm
No. 40

Lola Alvarez Bravo
Mexican, 1907–1993
Frida Kahlo, 1940s
gelatin silver print
8⁷⁄₁₆ x 6³⁄₈ inches
21.4 x 16.2 cm
No. 18

Diane Arbus
American, 1923–1971
printed 1970s
Loser at a Diaper Derby,
1967
gelatin silver print
15³⁄₄ x 16 inches
40 x 40.6 cm
No. 11

Gertrud Arndt
German, born 1903
Self-Portrait with Veil, 1930
gelatin silver print
9 x 5⁵⁄₈ inches
22.9 x 14.3 cm
No. 68

Tina Barney
American, born 1945
The Skier, 1987
chromogenic color print
29¹³⁄₁₆ x 39¹⁄₈ inches
75.7 x 99.4 cm
No. 35

Uta Barth
American, b. Germany 1958
Ground #57, 1994
chromogenic color print
19⁷⁄₈ x 23 inches
50.5 x 58.4 cm
No. 43

Jessie Tarbox Beals
American, 1870–1942
*Untitled (Little Girl with
Hairbow),* 1908
platinum print
8⁷⁄₈ x 6⁵⁄₈ inches
22.5 x 16.8 cm
No. 15

Ilse Bing
American (born Germany),
1899
Christa on Edge of Bathtub,
1934
solarized gelatin silver print
11¹⁄₈ x 8¹³⁄₁₆ inches
28.3 x 22.4 cm
No. 14

Margaret Bourke-White
American, 1904–1971
Woman, Locket, Georgia, 1936
gelatin silver print
13 x 9³⁄₄ inches
33.0 x 24.8 cm
No. 21

Anne W. Brigman
American, 1869–1950
The Heart of the Storm, 1910
gelatin silver print
9⁷⁄₈ x 7⁷⁄₈ inches
25.1 x 20 cm
No. 79

Esther Bubley
American, born 1921
Bus Story, NYC, 1943
gelatin silver print
13⁵⁄₁₆ x 8⁷⁄₈ inches
33.8 x 22.5 cm
No. 4

Debbie Fleming Caffery
American, born 1948
Praying, 1976
gelatin silver print
19¹⁄₈ x 19 inches
48.6 x 48.3 cm
No. 29

**Claude Cahun (Lucy
Schwob)**
French, 1894–1954
M.R.M. (Sex), 1936
gelatin silver print
6 x 4 inches
15.2 x 10.2 cm
No. 66

Marie Cosindas
American
Masks, 1966
dye transfer print
10 x 7³⁄₄ inches
25.4 x 19.7 cm
No. 57

Eileen Cowin
American, born 1947
*Untitled (Dripping Hands,
Praying Mantis),* 1994
gelatin silver print
10⁷⁄₈ x 27⁷⁄₈ inches
27.6 x 70.8 cm
No. 39

Imogen Cunningham
American, 1883–1976
Three Harps, 1935
gelatin silver print
9⁵⁄₈ x 7⁵⁄₈ inches
24.4 x 19.4 cm
No. 49

Aya Dorit Cypis
American, born 1951
*The Body in the Picture:
Bridget Shields,* 1993
chromogenic color print
19¹⁄₂ x 23¹⁄₂ inches
49.5 x 59.7 cm
(matte: 37¹⁄₂ x 29¹⁄₄ inches;
95.3 x 74.3 cm)
No. 27

Nell Dorr
American, 1893/5–1988
*Mother and Child
(Happiness),* 1940s
gelatin silver print
13¹⁵⁄₁₆ x 10¹³⁄₁₆ inches
35.4 x 27.5 cm
No. 33

Jeanne Dunning
American, born 1960
Leaking 2, 1994
pair of silver dye bleach
prints
21¹⁄₂ x 17¹⁄₂ inches (each)
54.6 x 44.5 cm (each)
No. 75

Barbara Ess
American, born 1948
Untitled, 1995
chromogenic color print
40 x 60 inches
101.6 x 152.4 cm
No. 47

Flor Garduño
Mexican, born 1957
The Woman, 1987
gelatin silver print
9 x 12⁷⁄₁₆ inches
22.9 x 31.6 cm
No. 19

Laura Gilpin
American, 1891–1979
Navaho Weaver, 1933
platinum print
13⅛ x 9⅜ inches
33.3 x 23.8 cm
No. 17

Nan Goldin
American, born 1953
*Gina at Bruce's Dinner Party,
NYC,* 1991
silver dye bleach print
25⅞ x 38½ inches
65.7 x 97.8 cm
No. 31

Jan Groover
American, born 1943
Untitled, 1979
chromogenic color print
14⅞ x 18¹³⁄₁₆ inches
37.8 x 47.8 cm
No. 54

Sandra Haber
American, born 1956
Untitled, 1987
chromogenic color print
6⅝ x 16½ inches
16.8 x 41.9 cm
No. 70

Florence Henri
Swiss (born U. S.),
1893–1982
Composition Nature Morte,
1931
gelatin silver print
3⅜ x 4½ inches
8.6 x 11.4 cm
No. 48

Candida Höfer
German, born 1944
Schloss, Weimar, 1991
chromogenic color print
14³⁄₁₆ x 20⁷⁄₁₆ inches
36 x 51.9 cm
No. 42

Kati Horna
Hungarian (born Spain),
1912 (active Mexico from
1939)
Doll Parts, 1933
gelatin silver print
7 x 7¾ inches
17.8 x 19.7 cm
No. 56

Graciela Iturbide
Mexican, born 1942
Mujercita, 1981
gelatin silver print
10⅛ x 6¾ inches
25.7 x 17.1 cm
No. 6

Lotte Jacobi
American (born Germany),
1896–1990
Child with Lollipop, 1934
gelatin silver print
6⁷⁄₁₆ x 7¹⁄₁₆ inches
16.3 x 17.9 cm
No. 9

**Frances Benjamin
Johnston**
American, 1864–1952
Penmanship Class, 1900
platinum print
7⅜ x 9⅜ inches
18.7 x 23.8 cm
No. 1

Consuelo Kanaga
American, 1894–1978
School Girl, St. Croix, 1963
gelatin silver print
12¹³⁄₁₆ x 8¹⁵⁄₁₆ inches
32.5 x 22.7 cm
No. 5

Gertrude Käsebier
American, 1852–1934
*Untitled (Portrait of a Young
Girl),* 1906
platinum print
9⅝ x 7⁷⁄₁₆ inches
24.4 x 18.9 cm
No. 16

Germaine Krull
French (born Poland),
1897–1985
*The Hands of the Actress
Jenny Burney,* 1928
gelatin silver print
6½ x 8⅝ inches
16.5 x 21.9 cm
No. 26

Dorothea Lange
American, 1895–1965
*Mother and Child, San Joaquin
Valley,* 1938
gelatin silver print
7 x 9½ inches
17.8 x 24.1 cm
No. 3

Alma Lavenson
American, 1897–1989
Self-Portrait, 1932
gelatin silver print
9 x 11¹⁵⁄₁₆ inches
22.9 x 30.3 cm
No. 65

Annie Leibovitz
American, born 1949
Jerry Garcia, NYC, 1973
gelatin silver print
12⁹⁄₁₆ x 18¼ inches
31.9 x 46.4 cm
No. 30

Helen Levitt
American, born 1913
Untitled, New York, 1940
gelatin silver print
6⅝ x 9⅝ inches
16.8 x 24.4 cm
No. 12

**Dora Maar (Dora
Markovik)**
French, born 1907
Mannequin in Window, 1935
gelatin silver print
9½ x 6 inches
24.1 x 15.2 cm
No. 55

Mary Ellen Mark
American, born 1940
Tiny, Halloween, 1983
gelatin silver print
13⁵⁄₁₆ x 9 inches
33.8 x 22.9 cm
No. 20

Margrethe Mather
American, 1885–1952
Buffie Johnson, Painter, 1933
gelatin silver print
3¾ x 2⅞ inches
9.5 x 7.3 cm
No. 28

Ana Mendieta
American (born Cuba),
1948–1985
Birth, from the *Isla* series,
1981
gelatin silver print
7¼ x 9⁹⁄₁₆ inches
18.4 x 24.3 cm
No. 80

Annette Messager
French, born 1943
Possession, from the series,
Mes Ouvrages, 1989
gelatin silver print and
mixed media
18 x 18 inches
45.7 x 45.7 cm
No. 38

Lisette Model
American (born Austria),
1901–1983
*Famous Gambler, French
Riviera,* 1934
gelatin silver print
13¾ x 10¾ inches
34.9 x 27.3 cm
No. 10

Tina Modotti
Italian, 1896–1942 (active
Mexico 1923–1930)
Yank and Police Marionette,
1929
gelatin silver print
9 x 7 inches
22.9 x 17.8 cm
No. 52

Lucia Moholy
British (born
Czechoslovakia), 1894–1989
Frau Finsler, 1926
gelatin silver print
7⅞ x 10 inches
20.0 x 25.4 cm
No. 24

Inge Morath
American (born Austria),
1923
*Siesta of a Lottery Ticket
Vendor, Plaza Mayor, Madrid,*
1955
gelatin silver print
7¼ x 4¹³⁄₁₆ inches
18.4 x 12.2 cm
No. 13

Barbara Morgan
American, 1900–1992
Corn Stalks Growing, 1945
gelatin silver print
12¹³⁄₁₆ x 9 inches
32.5 x 22.9 cm
No. 51

Joan Myers
American, born 1944
Pan and Cup, from the
Japanese Camp series, 1984
gelatin silver print
7 x 8⅞ inches
17.8 x 22.5 cm
No. 44

Nelly (Elli Seraïdari)
Greek (born Turkey), 1899
*The Russian Dancer Nikolska
at the Parthenon,* 1929
gelatin silver print
6⅜ x 8⅞ inches
16.2 x 22.5 cm
No. 64

Anne Noggle
American, born 1922
Shirley Condit deGonzales,
from the book *For God,
Country and the Thrill of It,*
1986
gelatin silver print
18⅛ x 13 inches
46 x 33 cm
No. 22

Barbara Norfleet
American, born 1926
*Benefit for the Mount Vernon
Ladies Association of the
Union, Copley Plaza Hotel,
Boston, Massachusetts* from
the book *All the Right People,*
1983
gelatin silver print
8¹⁵⁄₁₆ x 12⁷⁄₁₆ inches
22.7 x 31.6 cm
No. 34

Dorothy Norman
American, 1905–1997
Walls, An American Place,
1940s
gelatin silver print
2⅞ x 3⅞ inches
7.3 x 9.8 cm
No. 41

Sonya Noskowiak
American, 1905–1975
Plant Detail, 1931
gelatin silver print
9¹¹⁄₁₆ x 7½ inches
24.6 x 19 cm
No. 50

Lorie Novak
American, born 1954
Self-Portraits, 1987
chromogenic color print
22½ x 18⁹⁄₁₆ inches
57.2 x 47.1 cm
No. 71

Catherine Opie
American, born 1961
Angela Scheirl, 1993
chromogenic color print
19⅞ x 15½ inches
50.5 x 39.4 cm
No. 23

Ruth Orkin
American, 1921–1985
American Girl in Italy, 1951
gelatin silver print
11¹⁵⁄₁₆ x 18½ inches
30.3 x 47 cm
No. 8

Olivia Parker
American, born 1941
At the Edge of the Garden,
1986
gelatin silver print
14⅝ x 11½ inches
37.1 x 29.2 cm
No. 58

**Marta María Pérez
Bravo**
Cuban, born 1959
*No vi con mis propios ojos (I
did not see with my own eyes),*
1991
gelatin silver print
20 x 15⅞ inches
50.8 x 40.3 cm
No. 78

Jane Reece
American, 1869–1961
Triangle Composition, 1922
gelatin silver print
10 x 7¾ inches
25.4 x 19.7 cm
No. 63

Ursula Richter
German, 1886–1946
Totentanz, 1926
gelatin silver print
3⅝ x 4⅞ inches
9.2 x 12.4 cm
No. 61

ringl + pit
Ellen Auerbach, German,
born 1906
Grete Stern, German,
born 1904
*Das Ei des Columbus
(Columbus's Egg),* 1930
gelatin silver print
9¼ x 7⅞ inches
23.5 x 20.0 cm
No. 60

ringl + pit
Ellen Auerbach, German,
born 1906
Grete Stern, German,
born 1904
Goggi, 1929
gelatin silver print
8⅞ x 5¹¹/₁₆ inches
22.5 x 14.4 cm
No. 25

Holly Roberts
American, born 1951
Sad Woman/Angry Man, 1992
oil on gelatin silver print
16 x 22¼ inches
40.6 x 56.5 cm
No. 37

Martha Rosler
American, born 1943
Red Stripe Kitchen from the
series, *Bringing the War
Home: House Beautiful,*
c.1969–72
chromogenic color print
23⅛ x 17¾ inches
58.7 x 45 cm
No. 45

Meridel Rubenstein
American, born 1948
Fatman with Edith, 1993
palladium print
23½ x 19¼ inches
59.7 x 48.9 cm
No. 46

Charlotte Rudolph
German, 1896–1983
*La Danseuse Margarete
Wallmann,* 1920s
gelatin silver print
4¼ x 2¹³/₁₆ inches
10.8 x 7.1 cm
No. 62

Cindy Sherman
American, born 1954
Untitled, from the *History
Portrait* series, 1989
chromogenic color print
21 x 30⅞ inches
53.3 x 78.4 cm
No. 69

Laurie Simmons
American, born 1949
Three Red Petit-Fours, 1990
silver dye bleach print
23 x 35 inches
58.4 x 88.9 cm
No. 77

Lorna Simpson
American, born 1960
Details, 1996
21 photogravures
10 x 8 inches (each)
25.4 x 20.3 cm (each)
No. 73

Sandy Skoglund
American, born 1946
Atomic Love, 1992
silver dye bleach print
48 x 63 inches
121.9 x 160.0 cm
No. 36

Sandy Skoglund
American, born 1946
At the Shore, 1994
silver dye bleach print
10⅝ x 13¾ inches
27 x 34.9 cm
No. 76

Ruth Thorne-Thomsen
American, born 1943
Flora Bella, 1987
gelatin silver print
4¾ x 3⅝ inches
12.1 x 9.2 cm
No. 81

Hulleah Tsinhnahjinnie
American, born 1954
Vanna Brown, Azteca Style,
1990
gelatin silver print photo-
collage
23⁹/₁₆ x 30 inches
59.8 x 76.2 cm
No. 74

Doris Ulmann
American, 1882–1934
South Carolina, 1929
platinum print
7⅞ x 6 inches
20 x 15.2 cm
No. 32

Margaret Watkins
Canadian, 1884–1969
*Untitled (Still Life with Mirrors
and Windows, NYC),* 1927
platinum print
6 x 8 inches
15.2 x 20.3 cm
No. 53

Carrie Mae Weems
American, born 1953
Untitled, from the *Kitchen
Table* series, 1990
gelatin silver print
27 x 27 inches
68.6 x 68.6 cm
No. 72

Hannah Wilke
American, 1940–1993
*S.O.S.—Starification Object
Series,* 1974
gelatin silver print
40⅛ x 26½ inches
101.9 x 67.3 cm
No. 67

Marion Post Wolcott
American, 1910–1990
Town Meeting, Vermont, 1940
gelatin silver print
9¹³/₁₆ x 13 inches
24.9 x 33 cm
No. 2

Mariana Yampolsky
Mexican (born U.S.), 1925
Mujeres Mazahua, 1989
gelatin silver print
13⅝ x 18½ inches
34.6 x 47 cm
No. 7

Yva (Else Simon)
German, 1900–1942
Untitled, 1935
gelatin silver print
9¼ x 6¹⁵/₁₆ inches
23.5 x 17.6 cm
No. 59

Photography Credits